BODY
LANGUAGE

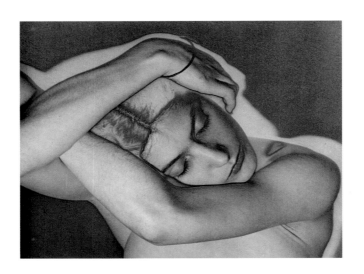

BODY
LANGUAGE

M. Darsie Alexander, Mary Chan, Starr Figura,
Sarah Ganz, and Maria del Carmen González,
with an introduction by John Elderfield

THE MUSEUM OF MODERN ART, NEW YORK

Distributed by Harry N. Abrams, Inc., New York

Published on the occasion of the exhibition
Modern Starts: *People, Places, Things*, at The Museum
of Modern Art, New York, October 7, 1999–March
14, 2000, organized by John Elderfield, Peter Reed,
Mary Chan, and Maria del Carmen González.

This exhibition is part of *MoMA2000*, which is made
possible by The Starr Foundation.

Generous support is provided by Agnes Gund and
Daniel Shapiro in memory of Louise Reinhardt Smith.

The Museum gratefully acknowledges the assistance
of the Contemporary Exhibition Fund of The Museum
of Modern Art, established with gifts from Lily
Auchincloss, Agnes Gund and Daniel Shapiro, and
Jo Carole and Ronald S. Lauder.

Additional funding is provided by the National
Endowment for the Arts and The Contemporary Arts
Council of The Museum of Modern Art.

Produced by the Department of Publications
The Museum of Modern Art, New York

Edited by Joanne Greenspun
Designed by Ed Pusz
Production by Christopher Zichello
Printed and bound by EuroGrafica SpA

This book was set in Adobe Minion, designed by
Robert Slimbach, and in FontShop Scala Sans,
by Martin Majoor. The paper is 150 gsm
Phoenix–Imperial.

Library of Congress Catalogue Card
Number: 99-75885

ISBN: 0-87070-026-X (MoMA)
ISBN: 0-8109-6305-5 (Abrams)

Published by The Museum of Modern Art
11 West 53 Street
New York, New York 10019
www.moma.org

Distributed in the United States and Canada
by Harry N. Abrams, Inc., New York
www.abramsbooks.com

Distributed outside the United States and Canada by
Thames & Hudson, Ltd, London

Printed in Italy

CONTENTS

INTRODUCTION

John Elderfield

Body language, in its popular understanding, refers to the messages that people's bodies send out unconsciously. The earliest citation of this phenomenon in the *Oxford English Dictionary* is to Shakespeare's *Troilus and Cressida* of 1606: "There's a language in her eye, her cheeks, her lip." The latest reference there dates to 1894, when an H. Drummond wrote, "A sign Language is of no use when one savage is at one end of a wood and his wife at the other." These two quotations allow us to associate the language of bodily signs with visual language in general: by nicely capturing, in the first, the immediacy of bodily signs and, in the second, the spatial dimension commonly thought essential to visual language. Such visual language is in contrast to the sequentiality and the temporal dimension commonly thought to lie at the essence of verbal language (an opposition that Leonardo da Vinci called a *paragone*).[1] However, the *Oxford English Dictionary* had not heard of the term "body language," which seems to be of modern coinage. It simply calls it "Language 1.b. Applied to methods of expressing the thoughts, feelings, wants, etc., otherwise than by words"—and has names only for the more specialized Finger-language (Dactylology) and the Language of Flowers.

I said that body language is popularly thought to be an unconsciously stated language. But the dictionary reference allows that it may be conscious. In a famous seventeenth-century account, the contrast between consciously and unconsciously stated language was a way of distinguishing men from animals: in Descartes's *Discourse on the Method*, we are told that animals differ from men in that "they never use words, or put together other signs, as we

do in order to declare our thoughts to others," and in that they act "not through understanding but only from the disposition of their organs . . . it is nature which acts in them."[2] But even Descartes had to acknowledge the fact that "I am not merely lodged with my body like a sailor in a ship, but am very closely united and as it were intermingled with it."[3] And in Freud's century, it is *consciously* intended body language that provokes suspicion. Dactylology may be practiced consciously, but body language is inauthentic if consciously intended: either deceitful, if it does not acknowledge that it is conscious, or affected, if it does. In the former instance, it is associable with politicians; in the latter, with body builders.

This book is about neither. It is about works of art that depict the human figure—either in part, or as a whole, or with other figures—and that express thoughts, feelings, wants, etc., otherwise than by words. In short, it is about figural depictions that tell stories. These figural depictions—paintings, sculptures, drawings, photographs, prints, film stills, posters—are in the collection of The Museum of Modern Art, and most of them date from a forty-year period that begins in 1880, which is the date when, in the main, the Museum's collection begins.[4] Even with these narrative figural depictions, however, the question of whether or not the represented body language is consciously intended to convey legible meanings is one that continues to make a difference. Obviously, any consciously made figural depiction will show a consciously intended figural depiction that expresses thoughts, feelings, wants, etc., otherwise than by words. The point, though, is whether or not the figural depiction does that through body language or through other means, say, through compositional or coloristic means.

Henri Matisse spoke for many modern artists when he wrote, in a now-famous quote, in 1908: "Expression, for me, does not reside in passion bursting from a human face or manifested by violent movement. The entire arrangement of my picture is expressive: the place occupied by the figures, the empty spaces around them, the proportions, all of that has its share."[5] In effect, he is asserting the priority to visual art of the immediacy and spatiality commonly thought essential to all visual art over the sequentiality and temporality commonly thought essential to all verbal art. He is opposed to expression that is "bursting," and expression that manifests itself in "violent movement"—that is to say, temporally manifested expression, which requires the viewer to imagine how a depicted movement fits into a sequence of movements that is not shown. What Matisse recommends is spatially manifested expression that can be grasped immediately, and that does not require the viewer to imagine some invisible sequence of movements.

And yet, as the works illustrated in this volume make manifestly clear, many modern artists continued to represent figures that do make such a demand of the viewer, that require the viewer to infer expressive meaning from the spatially frozen figurative representation by imagining the temporal

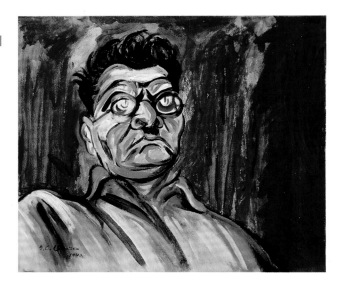

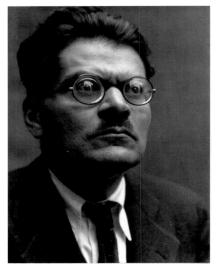

ABOVE, LEFT: JOSÉ CLEMENTE OROZCO.
Self-Portrait. 1940. Oil and gouache on cardboard,
mounted on composition board, 20 1/4 x 23 3/4"
(51.4 x 60.3 cm). The Museum of Modern Art,
New York. Inter-American Fund

ABOVE, RIGHT: EDWARD WESTON. **José Clemente**
Orozco. 1930. Gelatin silver print, 9 11/16 x 7 7/16"
(24.6 x 18.9 cm). The Museum of Modern Art,
New York. Purchase

context to which the frozen moment belongs. Thus, the tradi-
tional means of figurative pictorial expression persisted into the
modern period: through the depiction of facial expression, of
gesture and posture, and through the pairing and grouping of
figures. Represented figures spoke through the language of the
body as well as through the language of their pictorial composi-
tion. Still, as the poet Geoffrey Hill puts it: "A poet's words and
rhythms are not his utterance so much as his resistance." [6]
Likewise, the representation of bodily eloquence provided a language for
modernist expression that was also a resistance against which modernist
expression was formed.

A simple example of this may be found in two far-from-simple portraits
of the painter José Clemente Orozco: one a self-portrait of 1940; the other a
photograph by Edward Weston, taken exactly a decade earlier. While clearing
from our minds any stray remnants of the prejudice that a photograph shows
a true likeness and a painting an interpretation, let us look just at the mouth.
We notice that the subject favored a certain stern haughtiness, which his own
representation of himself makes much of and which Weston allows, only to
ameliorate in the service of a kinder look. As is traditional to a figural art, we
put ourselves in the place of what is enacted; in this case, imagining what a
mouth in that shape feels like. Orozco must have felt that shape as he painted
not only his own mouth but also his collar and his forehead. Weston saw that
it might usefully be obscured a little, as well as softened, thus refusing to give
way to his subject's self-caricature.

Both the Orozco and the Weston offer readily legible images. We see in
the comparison how the language of facial expression has been manipulated,
but the language itself is fairly unambiguous. However, to look at two more

similar works—Ben Shahn's painting *Man* of 1946 and Dorothea Lange's photograph *Migratory Cotton Picker, Eloy, Arizona,* of 1940—is to see that one of them is extremely ambiguous. The Shahn shows a traditional gesture of pensive thought, the hand raised to cover the mouth, which is emphasized by an intense gaze and a furrowed brow. But the Lange is puzzling. The out-turned hand exposes a dry, worn palm; this is, indeed, a worker's hand, as the title of the photograph tells us. But the action is illegible. We cannot tell from the frozen gesture what has either preceded or will follow it, and without an understanding of that temporal sequence, we cannot tell what is happening: the man may be wiping his mouth, or he may be sorrowful, or he may be attempting to hide from danger or from the camera.

Some gestures are natural and anatomically determined. Others are the products of social or cultural conventions. In either case, figurative artists have long followed Leonardo da Vinci's advice to "take pleasure in carefully watching those who talk together with gesticulating hands and get near to listen what makes them make the particular gesture."[7] (It needs saying, of course, that Leonardo was observing Italians, and that there is a long-standing European division between north and south when it comes to gesture, although in the later twentieth century the British self-definition of themselves as peerless among the non-gesticulators did begin to dwindle.)[8] Yet, figurative artists have also long used their observation of "talking" gestures to learn to depict, at times, gestures whose meanings are extremely unclear; Leonardo himself was one such artist. It may reasonably be said, though, that ambiguous gestures appear more frequently in modern art. Photography, certainly, will often exploit how a temporal sequence is suspended when the shutter falls, and, hence, will stop and preserve a moment of a movement that, taken alone, can be utterly obscure and captivating for that reason.

Yet, as another comparison of a painting and a photograph shows, the former medium, too, has found that depiction of an ambiguously suspended moment offers the valuable pictorial purpose of creating uncertainty in the mind of the viewer, and

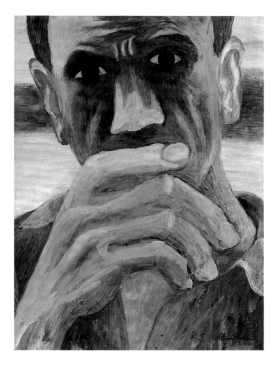

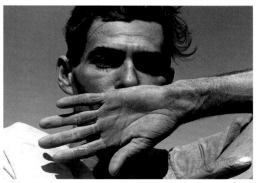

TOP: BEN SHAHN. *Man.* 1946. Tempera on composition board, 22 7/8 x 16 3/8" (57.9 x 41.5 cm). The Museum of Modern Art, New York. Gift of Mr. and Mrs. E. Powis Jones

ABOVE: DOROTHEA LANGE. *Migratory Cotton Picker, Eloy, Arizona.* 1940. Gelatin silver print, 10 1/2 x 13 1/2" (26.6 x 34.8 cm). The Museum of Modern Art, New York. Gift of the photographer

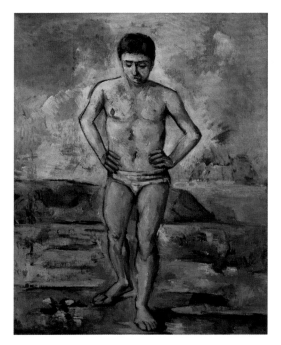

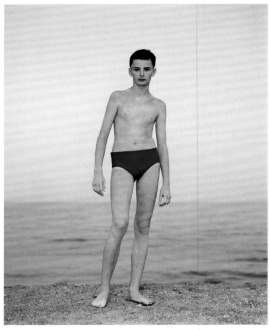

ABOVE, LEFT: PAUL CÉZANNE. *The Bather.* c. 1885.
Oil on canvas, 50 x 38 ⅛" (127 x 96.8 cm). The
Museum of Modern Art, New York. Lillie P. Bliss
Collection

ABOVE, RIGHT: RINEKE DIJKSTRA. **Odessa, Ukraine.**
4 August 1993. 1993. Chromogenic color print,
46 ³/₈ x 37" (117.8 x 94 cm). The Museum of Modern
Art, New York. Gift of Agnes Gund

therefore of maintaining and extending the viewer's engagement with the painting. Paul Cézanne's *Bather* of about 1885 does this just as much as does Rineke Dijkstra's *Odessa, Ukraine. 4 August 1993.*

The pose in the Cézanne goes back to a celebrated pose from classical antiquity that made use of what the German eighteenth-century aesthetician G. E. Lessing would describe as the "Classical moment." This required posing a figure as if in a moment of time between one preceding and one succeeding intelligible movement. And it relies upon our reading the entire movement from our empathetic response to the shape of the figure, as shown. In the case of the Cézanne, we can thus read the figure as poised between standing and taking a step. Yet, the figure seems immovably pasted onto the surface, caught there in unknowable thoughts, and we must scan the entire arrangement of the picture for its expressive meaning: the place occupied by the figure, the empty spaces around him, the proportions—all of that has its share. And it is because the posture is a traditionally meaningful one that it offers such meaningful resistance to the artist. Although the figure depicted in Dijkstra's photograph is as individual and awkward as that in Cézanne's painting is general and secure, it, too, gains a meaningful resistance from the long tradition of posed figural images, as well as from the shorter, modern tradition inaugurated by Cézanne. Certainly, it is as resistant to our understanding of what precisely was the cause of the pose.

It is expected that we will ponder the cause; the work's invitation that we do so is the artist's invitation that we ponder the work. When more than one figure is represented, however, even the most negligent or most resistant of viewers can hardly escape pondering the causal relationships in the work. Seeing things brought together, it is natural to infer a cause.

Even without the title, Aristide Maillol's relief *Desire* of 1906–08 does not offer much difficulty in this respect. The first usual interpretation of this work—that the man desires and the woman resists the desire—will be confounded once one begins to notice the sequence of formal analogies between their respective postures and, especially, their mutually tangential forms. Thus, his right leg and her right leg share a common contour, while her left leg is the mirror of his right. And thus each of the two figures reinforces the presence of the other, and a mutual connectiveness is described in the playfulness with which form matches form, form contacts form, and the multiple matchings and contacts produce multiple new forms.[9] Henri Cartier-Bresson's *Italy* of 1933 is more difficult to read, but not necessarily more ambiguous. As with the Dijkstra, a place is substituted in the title for the expected human description. This invites us to wonder not only about two apparently nude figures in the water, one wrapped around the other, laid back with arms thrown outward to help to float, but about two presumably Italian such figures. So, remembering something said earlier, we start to see gesticulating arms, and a conversation, not only a seduction or a swimming lesson, in the shape.

Unquestionably, strong formal considerations underlie the arrangement of both sets of paired bodies. Something stilled in action in such a way as to suspend—not explain—the propulsion of the narrative will encourage the contemplation of the shape. A final pair of examples can demonstrate this.

BELOW, LEFT: ARISTIDE MAILLOL. *Desire.* 1906–08. Tinted plaster relief, 46 7/8 x 45 x 4 3/4" (119.1 x 114.3 x 12.1 cm). The Museum of Modern Art, New York. Gift of the artist

BELOW, RIGHT: HENRI CARTIER-BRESSON. *Italy.* 1933. Gelatin silver print, printed 1986, 9 7/16 x 14" (24 x 35.6 cm). The Museum of Modern Art, New York. Lois and Bruce Zenkel Fund

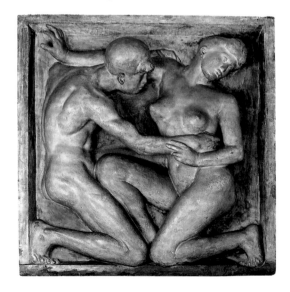

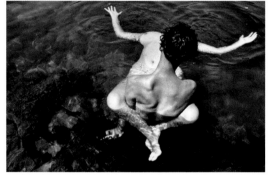

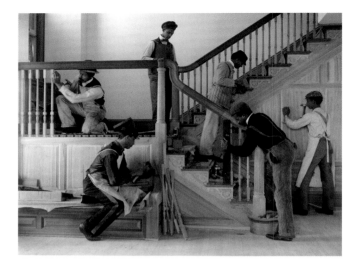

FRANCES BENJAMIN JOHNSTON. **Stairway of
Treasurer's Residence: Students at Work.** 1899–1900.
From *The Hampton Album*. 1900. Platinum print,
7 $\frac{1}{2}$ x 9 $\frac{1}{2}$" (19.1 x 24.1 cm). The Museum of Modern
Art, New York. Gift of Lincoln Kirstein

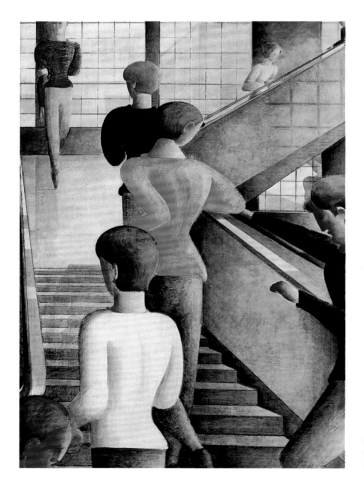

OSKAR SCHLEMMER. **Bauhaus Stairway.** 1932. Oil
on canvas, 63 $\frac{7}{8}$ x 45" (162.3 x 114.3 cm). The Museum
of Modern Art, New York. Gift of Philip Johnson

Both Frances Benjamin Johnston's *Stairway of Treasurer's Residence: Students at Work* of 1899–1900 and Oskar Schlemmer's *Bauhaus Stairway* of 1932 clearly show stilled actions. Part of the wonder of both works is that it is as if time suddenly has stopped in them, and has stopped forever, so that these figures will never move again. These figures will, indeed, forever be shapes on staircases. And yet, especially when a number of figures are shown, it is natural to imagine a narrative. In the case of the Johnston, one imagines the efficiency of the hammering and the building, and that it is as repetitively organized and beautifully executed as this photograph is. And, in the case of the Schlemmer, one imagines the kind of painting the members of the Bauhaus will make when they get to the top of the staircase, and concludes that it will look like this painting. Thus, these images resemble the narratives that they call up. Of course, it is the architectural as well as bodily language represented in them that contributes to this effect. Yet, the body language of Johnston's and Schlemmer's figures tells us that they are the sort of people who would make the sort of things we are looking at. They are stand-ins for their artists, busily making things or busily rushing to work.

The retentive reader will have noticed that the five pairs of examples I have briefly discussed correspond to the five channels of bodily eloquence mentioned earlier, namely, facial expression, gesture, posture, pairs, and groups. This five-part division produced the organizing principle of this book. The works illustrated in the pages that follow are, therefore, divided into five sections devoted to these subjects, with ten pairs of illustrations in each. Two pairs of illustrations in each section have commentaries by the person who chose the illustrations for that section. Their aim is to suggest possible ways of looking at the subjects of these commentaries, and to encourage the reader to look with a similar curiosity at the other works.

The attentive reader will have noticed that my five pairs of examples all compare paintings (or a sculpture) with photographs. This is not typical of the pairs of images that follow, but it has served the purpose, I hope, of asserting that similar issues attend the painterly manufacture and the photographic record of the language of the body; that both partake of the same tradition; that both resist it, albeit in different ways. In both, certainly, we are regularly faced with the so-called iconic defeat that modern art imposes upon its viewers, as we puzzle at what the body language actually means. And, puzzling, we soon learn that the not-so-hidden message of the language, in addition to its narrative description, is to keep us reading otherwise than by words.

1. See W. J. T. Mitchell, *Iconology: Image, Text, Ideology* (Chicago: University of Chicago Press, 1986).

2. René Descartes, *The Philosophical Writings of Descartes*, vol. 1 (Cambridge, Eng.: Cambridge University Press, 1985), pp. 140–41.

3. René Descartes, *Meditations and Other Metaphysical Writings*, translated with an introduction by Desmond M. Clarke (London: Penguin, 1998).

4. Thus, the present publication is intended to complement the People section of Modern*Starts: People, Places, Things* (New York: The Museum of Modern Art, 1999), which offers further examples and discussion of body language. My introduction to that section, "Representing People: The Story and the Sensation," is complementary in some respects to this present Introduction.

5. Dominique Fourcade, ed., *Henri Matisse: Écrits et propos sur l'art*, rev. ed. (Paris: Hermann, 1992), p. 42.

6. Geoffrey Hill, *The Enemy's Country: Words, Contexture, and Other Circumstances of Language* (Stanford, Calif.: Stanford University Press, 1995).

7. Leonardo da Vinci, *Treatise on Painting* (fol. 25), ed. A. P. McMahon (Princeton, N. J.: Princeton University Press, 1956).

8. See Keith Thomas, "Introduction," in Jan Bremmer and Herman Roodenburg, *A Cultural History of Gesture* (Ithaca, N.Y.: Cornell University Press), pp. 9–10. This useful book has an excellent bibliography.

9. Cf. Leo Bersani and Ulysse Dutoit, *The Forms of Violence: Narrative in Assyrian Art and Modern Culture* (New York: Schocken, 1985), p. 20, and passim for discussion of visual narrative and its vicissitudes.

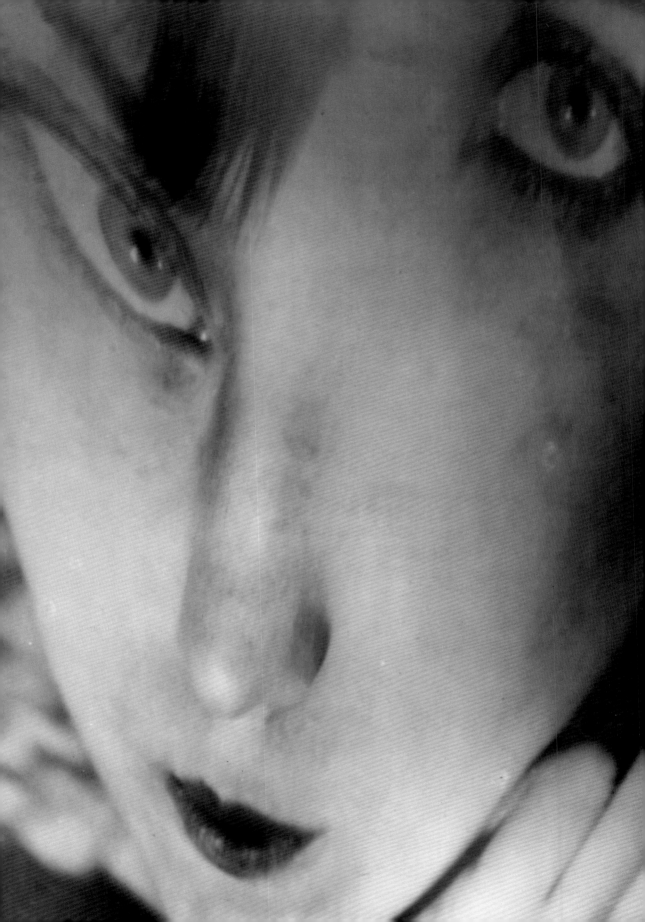

FACES

Berenice Abbott, *Portrait of the Artist*
Henri Matisse, *White Mask on Black Background*

Mary Chan

Berenice Abbott's photograph *Portrait of the Artist* and Henri Matisse's aquatint *White Mask on Black Background* exhibit striking formal similarities (pp. 18–19). Both are close-up images of slightly angled faces with assymetrically positioned eyes, long, straight noses, and dark upturned lips. These black-and-white compositions manipulate the technical possibilities of their respective mediums to abstract the human facial features to different ends. A comparison of the two invites an exploration of the notion of the mask—whether it is directly portrayed or suggested through pictorial illusion.

Among all the fine arts, photography is best suited to render natural appearances faithfully, particularly in portraiture. In this case, Abbott uses the camera to distort her own self-image. She dramatically skews the proportions of her face, which is dominated by the misshapen eyes—the sharp diagonal of the left eye leading our attention down toward her exaggeratedly tapered chin. Her head is propped up on her folded hand, its narrow fingers blending into the wavy pattern of her clothing. This stylized fracturing of form, while reminiscent of Cubist works, readily suggests the influence of Man Ray's Surrealist innovations and fashion photography. Indeed, Abbott worked as an assistant to Man Ray in Paris from 1923 to 1925. The avant-garde photographer hired her because of her ignorance of photography, feeling that she could be easily trained; yet within two years Abbott had fostered her own portraiture clientele, eventually establishing her own studio in 1926. She made her reputation from straightforward photographs that capture the essence of the personalities of the artistic and literary figures of Paris. In this remarkable self-portrait, however, Abbott abandons her signature restrained style.

The photograph most likely belongs to a group of self-portraits created by Abbott beginning in the 1940s, by which time she had returned to New York. During this period, American photography embraced a visual experimentation indicative of stylistic advances occurring in the visual arts in general. Frustrated by existing photographic equipment, Abbott founded a company called the House of Photography, where she developed ideas for new processes. One apparatus, the distortion easel, allowed for the doctoring of the surface of prints while they were being developed in the darkroom, resulting in extreme images, such as *Portrait of the Artist*. Although she received a patent for the distortion easel in the early 1950s, it—like her other inventions—failed to sell.[1] What may one construe from this decomposition of the self-portrait by an artist who extolled the virtues of realism in photography?[2] The deliberate transformation of her face may be analyzed in terms of a kind of masking since it bars a true reading of her bearing or physical characteristics. In this sense,

the feeling of disjunction and flux suggests a non-fixed identity removed from conventional boundaries of feminine depiction. Thus in this experimentation with her own image, a course she seems not to have usually taken with her portraits of others, we are tempted to locate the personal within an ostensibly formal investigation.

The disembodied, stark white face set against the dense, subtly lined black background in the Matisse print has been described as analogous to an image of the moon floating in the night sky. It is the last in a series of aquatint heads composed of heavily applied black lines on white paper, all exemplifying the simplicity of line employed by the artist to delineate the features of the human face. Whereas a degree of the individuality of his subjects was retained in the preceding aquatint heads, here, in the image of a mask, Matisse has created a powerful emblem of a face.

Matisse returned to the mask in numerous cutouts, prints, and drawings during the late 1940s to early 1950s. These include the cutouts *The Eskimo* (1947), *Negro Mask* (1950), and *Japanese Mask* (1950); lithographs of Eskimos (1949) illustrating a novel by Georges Duthuit about an imaginary Arctic trip; and brush and ink drawings similar to the faces executed in charcoal on his bedroom ceiling. In the context of these other works, Matisse may also have intended this particular mask to bear connotations of the foreign, with attendant implications of the exotic and primitive. Yet in contrast to those based on specific cultural artifacts, this mask, with its rudimentary features, imparts a certain disquietude. Earlier in his career, Matisse conferred abstracted, masklike faces upon several of his portrait subjects of the 1910s, thus erecting a barrier that obstructs communication with the viewer. Now, near the end of his life, he further abstracts the face, eliminating any external context and so projecting a stronger feeling of remoteness.

There is something unsettling about both the Abbott and the Matisse images. Although Abbott was never associated with Surrealism, the disorientation that she conjures in her photograph corresponds to the inclination toward the hallucinatory and subjective typical of that aesthetic movement. Because it is a self-portrait, these elements encourage one to look beyond the purely formal in search of clues to the articulation of her identity as an artist and as an independent woman. Matisse, on the other hand, exploits the forceful resonance of black and white to produce a generalized likeness of a face, converting universal facial characteristics into an object meant to disguise or alter identity. In these extraordinary examples of modern renderings of the same motif, we are thus confronted with the expressive potential and ultimate mystery inherent in the human face.

1. The distortion easel is reproduced in Hank O'Neal, *Berenice Abbott: Sixty Years of Photography* (London: Thames & Hudson, 1982), p. 25.
2. Berenice Abbott, *A Guide to Better Photography* (New York: Crown, 1941).

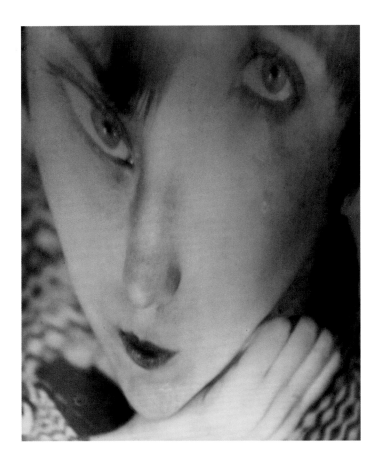

BERENICE ABBOTT
Portrait of the Artist. c. 1950.
Gelatin silver print, 12¹³/₁₆ x 10¹/₈" (32.5 x 25.7 cm).
The Museum of Modern Art, New York.
Frances Keech Fund in honor of Monroe Wheeler

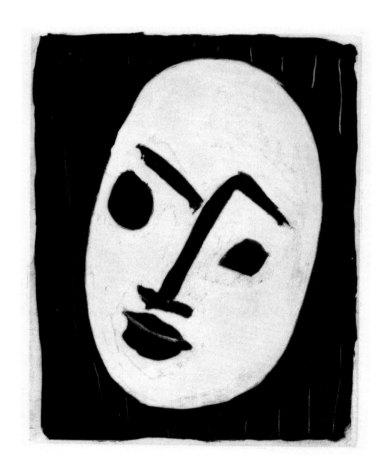

HENRI MATISSE
White Mask on Black Background. 1949–50,
printed 1966.
Aquatint, plate: 12$^1/_2$ x 9$^3/_4$" (31.7 x 24.8 cm).
Edition: 25. The Museum of Modern Art, New York.
Purchased with funds given by Harry Kahn, Susan
and Arthur L. Fleischer, Jr., Carol and Bert Freidus,
Johanna and Leslie J. Garfield, Linda and Bill Goldstein,
Francine E. Lembo, Barbara and Max Pine, and Susan
and Peter A. Ralston in honor of Riva Castleman

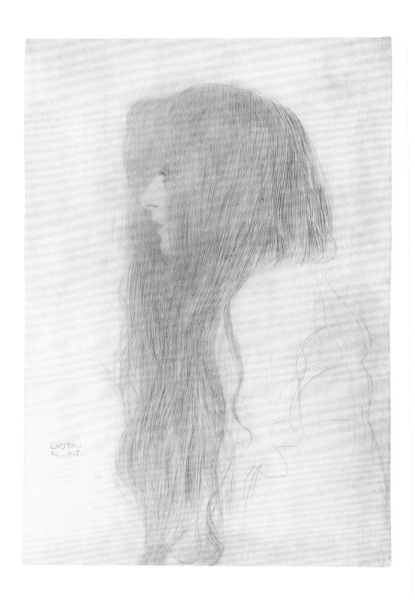

GUSTAV KLIMT
Woman in Profile. 1898–99.
Colored pencil on paper, 16 7/8 x 11 3/8" (42.8 x 28.7 cm).
The Museum of Modern Art, New York. The Joan and
Lester Avnet Collection

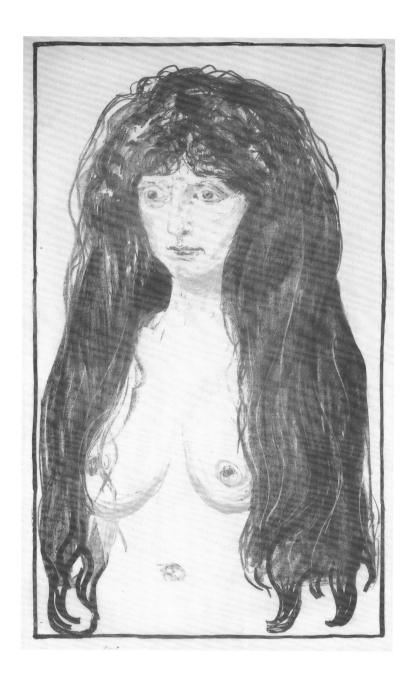

EDVARD MUNCH
Nude Figure (Sin). c. 1902.
Lithograph, comp.: $27^3/8$ x $15^{13}/16$" (69.5 x 40.2 cm).
Printer: Lassally, Berlin. Edition: more than 100.
The Museum of Modern Art, New York. Gift of
James Thrall Soby

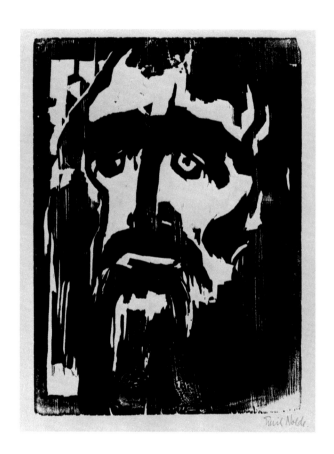

EMIL NOLDE
Prophet. 1912
Woodcut, comp.: 12⅝ x 8¾" (32.1 x 22.2 cm).
The Museum of Modern Art, New York. Given
anonymously (by exchange)

Edward Steichen
Sunburn. c. 1925.
Gelatin silver print, printed later, 13⅝ x 10¾"
(34.6 x 27.3 cm). The Museum of Modern Art,
New York. Gift of the photographer

JOHN D. GRAHAM
Study after *Celia*. 1944–45.
Pencil on tracing paper, 22⁷/₈ x 18³/₄" (58.2 x
47.7 cm). The Museum of Modern Art, New York.
The Joan and Lester Avnet Collection

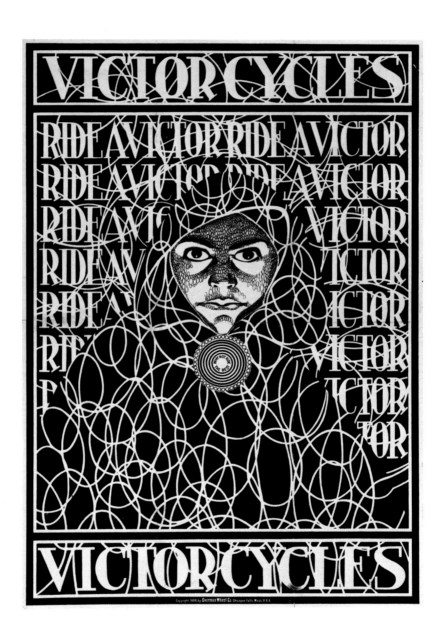

MAX KLINGER, *Going Under*
ROY LICHTENSTEIN, *Drowning Girl*

Mary Chan

Separated in date by more than seventy-five years, Max Klinger's *Going Under* of 1884 and Roy Lichtenstein's *Drowning Girl* of 1963 are images of women submerged in water, both victims of doomed love (pp. 30–31). Whereas *Going Under* is part of an allegorical cycle of etchings tracing a woman's downfall to prostitution and ruin, and *Drowning Girl* is one of many canvases of women based on comic-book characters, their extreme differences in artistic intent correspond to a shared social critique, the former of late-nineteenth-century bourgeois moral hypocrisy and the latter of early 1960s female stereotypes.

In Klinger's etching, the woman's face seems just on the verge of sinking below the surface of the water. With her head tilted slightly back, water begins to seep into her open mouth, and her wide eyes simultaneously express fear and resignation. Framing the small head and reflecting the anguish of its expression, the dark ripples of water and the overcast night sky dominate the composition. The ominous physical presence of these natural elements is graphically accentuated by the nervously flowing lines of the moving water coupled with the thin cross-hatchings of the near-black horizon. *Untergang*, the original German title of this print, and its English translation, are an obvious literal reference to the scene depicted but also a symbolic allusion to the social undoing narrated in the entire cycle, called *A Life*. In fifteen plates, Klinger presents the story of a woman seduced and deserted by her lover, forced to support herself as a prostitute, ostracized by both the lower and upper tiers of society, driven to suicide, and finally delivered to a cold, unforgiving afterlife. Water plays a role in two other prints from the series: the lovers are imagined intertwined beneath the sea and, after her abandonment, the woman stands staring into the vast ocean—a familiar motif in German Romantic art.

Klinger produced a number of print series, all incorporating the devices of exaggeration and fantasy, which the artist felt could better communicate his personal outlook on life as opposed to the mediums of painting and sculpture. In *A Life*, supposedly based on newspaper accounts,[1] he sought to blend a dreamlike chronicle with a harshly realistic commentary on women's plight in society. The fallen woman was a common nineteenth-century preoccupation because of the belief that a woman's innate instability coupled with the temptation of her sexuality could contribute to her downfall. Klinger's fixation with the concepts of love, sex, and death is indicative of the changing social mores of the time. Additionally, his expression of their manifestations upon the human psyche and the infusion of his works with a lingering sense of foreboding align him with the Symbolist movement.

Lichtenstein's painting zeroes in on the face of the drowning girl, encircling it with crashing waves. The balloon at the top revealing her thoughts immediately sets the ironic tone for the work, as the drama of the event is mitigated by the silliness of her reaction. This composition derives from one frame in a romance comic book showing a girl in the foreground with her boyfriend looking on from a capsized boat. By reducing the narrative context, Lichtenstein takes the comic-strip genre one step further from reality until we are confronted only with the iconic image of the crying girl: her tears, facsimiles of the white waves, do not spoil the mascara on her full eyelashes. The enlarged scale of the Benday dots and the cartoon patterns of curves for the hair and water, the heavy black outlines, and the blue color of the perfectly coiffed hair heighten the sense of the absurd. Lichtenstein remarked upon his conscious effort to approximate the waves in nineteenth-century Japanese woodcuts by Hokusai. "The original wasn't very clear in this regard—why should it be? I saw it and pushed it a little further until it was a reference that most people would get . . . it is a way of crystallizing the style by exaggeration."[2]

By reinforcing the artificiality of their representation, Lichtenstein emphasizes the idea of women as weak and emotional, conventional assumptions perpetuated in the mass media of the 1960s. *Drowning Girl* is one of numerous paintings from 1963–65 with female protagonists who are desperate, passive players in their relationships with men. His sophisticated take on the American cliché of femininity during a time when the women's movement had not yet assumed force signals one facet of Pop art's cynical attitude toward the postwar mindset.

From these two faces of desperate women, the viewer may infer two very different stories and two kinds of judgment on the part of their male creators. Klinger's work, based on a tradition of illustrated morality tales, requires knowledge of the entire sequence of etchings in order to convey its angst-ridden message. This heavy-handed picturing of death in a metaphorical ocean of suffering is meant to elicit sympathy. Meanwhile, Lichtenstein's deadpan rendering of the drowning girl denies any emotional connection. Its humorous appropriation of popular imagery stems from the fundamental aim to provide a picture of consumer society within the realm of high art, but may also be read as a pointed commentary on contemporaneous estimations of women's vulnerability. Thus, on one hand, woman is martyred by the fault of society at large while, on the other, woman is done in by her own shallowness, a trait underscored in the wider culture that she represents, the very culture that invented her as a type.

1. Memory Jockisch Holloway, *Max Klinger: Love, Death and the Beyond* (Melbourne: National Gallery of Victoria, 1981), p. 2.
2. Quoted in John Coplans, "Talking with Roy Lichtenstein," originally published in *Artforum*, no. 9 (May 1967); reprinted in John Coplans, ed. *Roy Lichtenstein* (New York: Praeger Publishers, 1972), p. 91.

Max Klinger
Going Under (Untergang), **plate 3 from** *A Life*
(Ein Leben). 1884.
Etching and aquatint, plate: 11^{1}/$_{16}$ x 9^{5}/$_{16}$" (28.2 x
23.6 cm). The Museum of Modern Art, New York.
Mrs. John D. Rockefeller 3rd Fund

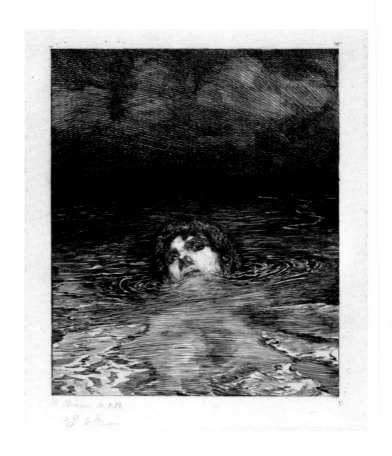

ROY LICHTENSTEIN
Drowning Girl. 1963.
Oil and synthetic polymer paint on canvas, 67⅝ x
66¾" (171.6 x 169.5 cm). The Museum of Modern
Art, New York. Philip Johnson Fund and gift of Mr.
and Mrs. Bagley Wright

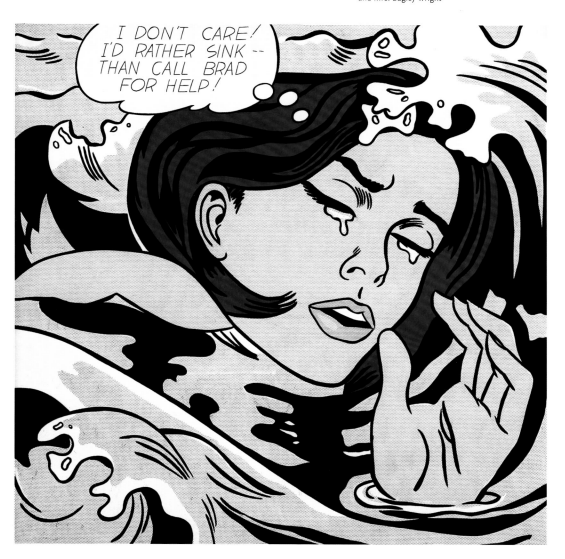

Bruce Nauman
Study for *Hologram* from the series *Studies for Holograms*. 1970.
Screenprint, comp: 20⁵/₁₆ x 26¹/₁₆" (51.6 x 66.2 cm).
Publishers: Castelli Graphics, New York. Printer: Aetna Studios, New York. Edition: 150. The Museum of Modern Art, New York. John B. Turner Fund

JEAN DUBUFFET
René Bertelé. 1947.
Reed pen and ink on paper, 13 1/4 x 9 5/8" (33.5 x
24.5 cm). The Museum of Modern Art, New York.
Gift of Heinz Berggruen, William S. Lieberman, and
Klaus Perls in memory of Frank Perls, art dealer

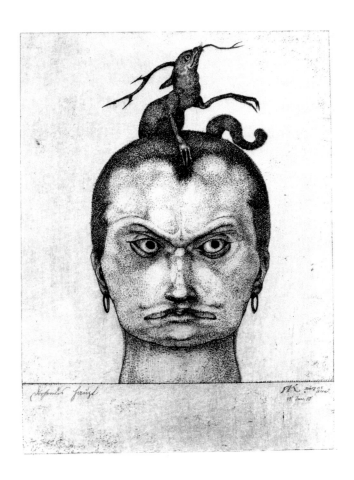

PAUL KLEE
*Menacing Head (**Drohendes Haupt**)*. 1905.
Etching, plate: 7¹¹/₁₆ x 5³/₄" (19.6 x 14.6 cm).
Printer: Max Giraret, Bern. Edition: 10.
The Museum of Modern Art, New York.
Abby Aldrich Rockefeller Fund

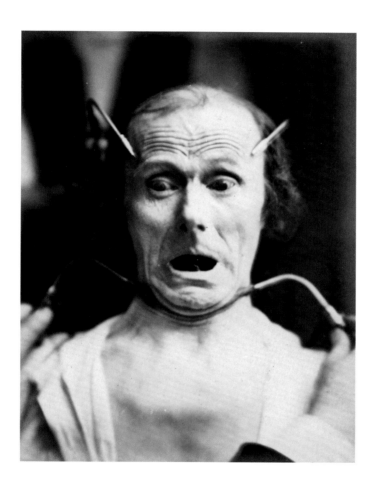

GUILLAUME-BENJAMIN-AMAND DUCHENNE DE
BOULOGNE
**Fright (Effroi) from Mécanisme de la physionomie
humaine**. 1862.
Albumen silver print from a wet-collodion glass
negative, 4³/₄ x 3¹¹/₁₆" (12.2 x 9.4 cm). The Museum
of Modern Art, New York. Gift of Paul F. Walter

MARC CHAGALL
Self-Portrait with Grimace (Selbstbildnis mit
Grimasse). c.1924–25.
Etching and aquatint, plate: 14^{11}/$_{16}$ x 10^{3}/$_{4}$" (37.3 x
27.4 cm). Printer: Louis Fort, Paris. Edition: 100.
The Museum of Modern Art, New York. Gift of the
artist

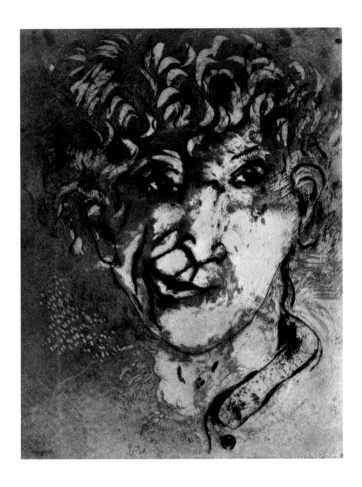

ÉMILE-ANTOINE BOURDELLE
Beethoven, Tragic Mask. 1901.
Bronze, 30$^1/_2$ x 17 x 17$^3/_4$" (77.4 x 43.2 x 45 cm).
The Museum of Modern Art, New York.
Grace Rainey Rogers Fund

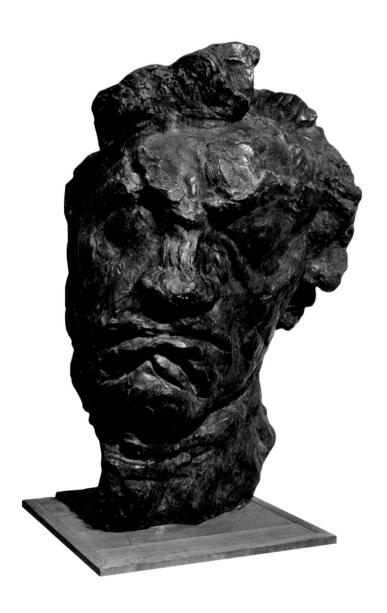

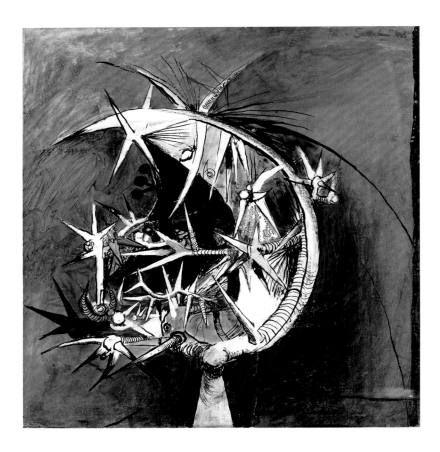

GRAHAM SUTHERLAND
Thorn Head. 1945.
Gouache, chalk, and ink on paper mounted on
board, 21⁷/₈ x 20⁷/₈" (55.4 x 53 cm). The Museum of
Modern Art, New York. James Thrall Soby Bequest

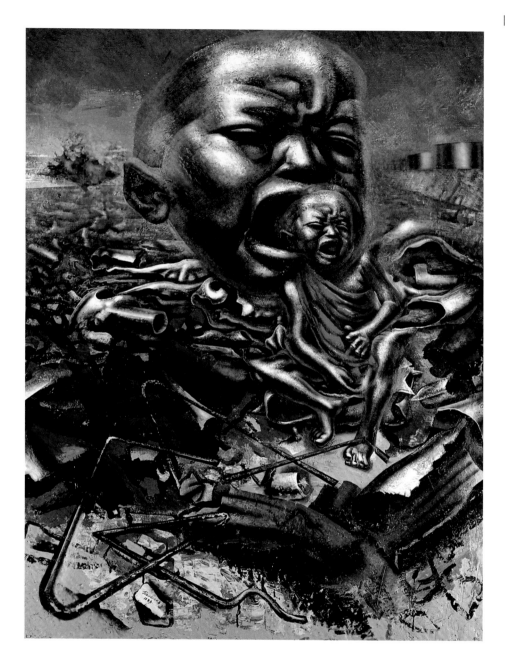

DAVID ALFARO SIQUEIROS
Echo of a Scream. 1937.
Enamel on wood, 48 x 36" (121.9 x 91.4 cm).
The Museum of Modern Art, New York. Gift of
Edward M. M. Warburg

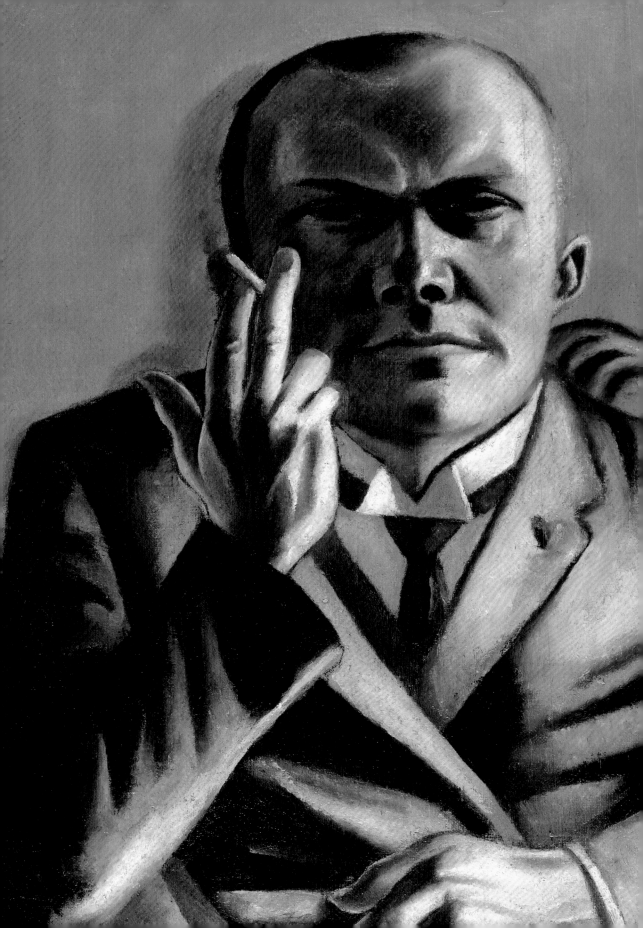

GESTURE

MAX BECKMANN, *Self-Portrait with a Cigarette*
CINDY SHERMAN, *Untitled #113*

Starr Figura

Smoking is an activity that has long been associated with particular social types, from the urbane sophisticate to the jaded individualist. Max Beckmann's *Self-Portrait with a Cigarette* and Cindy Sherman's *Untitled #113* are self-portraits (although the latter is not so in a traditional sense) that exploit these associations to convey subtle social and psychological truths (pp. 44–45). They also use self-portraiture as a means of probing unconscious assumptions about reality and representation. As Beckmann stated, "What I want to show in my work is the idea that hides itself behind so-called reality. . . . Like the famous kabbalist who once said: 'If you wish to get hold of the invisible you must penetrate as deeply as possible into the visible.'"[1]

Beckmann created more than eighty self-portraits in paintings, prints, and drawings. In the early 1920s, when this work was painted, he was readjusting to middle-class life and reestablishing himself as a successful artist after having lived through the confusion and shock of the immediate post–World War I years. The violence and inhumanity of the war had permanently shaken his faith in the values of society and culture.[2] But while his self-portraits from the 1910s often reveal a vulnerable side, here Beckmann's stern, unflinching visage and hard, rectangular form indicate that he now views himself in almost heroic terms, and he plays with the disguise of absolute power. His dapper clothing connotes prosperity and control; his masklike face is inscrutable, even sinister; and his stare is so penetrating that it seems to somehow implicate the viewer. His right arm, holding the cigarette, is raised in a gesture that signals confrontation and defiance as much as it does smoking. By presenting himself against a gold background reminiscent of medieval icons, he subliminally implies his own saintliness or martyrdom. Although Beckmann continues to view the world in tragic terms, he is not a victim but an all-seeing and unforgiving judge.

Sixty years later, Sherman cast herself in a different, yet curiously parallel, role, that of the mysteriously aloof but vulnerable tough girl, a romantic stereotype familiar to audiences of film and television. One of several artists working in the 1980s and 1990s who use their own bodies as subject matter, Sherman has photographed herself in guises that subvert the ways in which women are typically portrayed in the media. In her groundbreaking series from 1977–80 called *Untitled Film Stills*, she assumed a variety of personas reminiscent of cinematic heroines from the 1950s and 1960s.

Untitled #113 is from a period in the early 1980s when Sherman began working in color and in larger, near-life-size dimensions. In it, she uses gesture in combination with makeup, clothing, lighting, and setting to create a specific emotional moment. The scene is intimate and personal, with curtains in the

background suggesting a behind-the-scenes stage break. The subject's clothes and hair look cheap and artificial, and her relaxed posture implies resignation and weariness. Her head is cocked to one side, and she glances up as if she has just been interrupted from reverie. But despite the intimation of privacy, her pose is mannered and self-conscious, for Sherman is projecting a persona rather than truly relaxing. By using photography—the medium through which this kind of stereotype has been glamourized and popularized—Sherman exploits and confounds our expectations of a "real" or truthful moment and thus reinforces the ambiguous sense of déjà vu that we experience in viewing her work.

Beckmann's painting reflects a similar fascination with theatrics and role-playing. In portraits and allegorical scenes from the postwar period on, he repeatedly represented himself in costumes of the circus, the cabaret, and other popular entertainments. The red polka-dot sash at the lower left is a sly reference to the attire of a clown, a motif which for Beckmann symbolized the tragicomic nature of humanity. Its presence adds an element of ambiguity to this otherwise authoritarian self-representation and reflects Beckmann's apprehension that there may be only a fine line between a serious artist and a charlatan.

For both artists, the use of disguise in conjunction with self-portraiture reveals a paradoxical compulsion toward both exhibitionism and concealment. The viewer's role is thus transferred from simple spectator to voyeur. In Beckmann's painting, it is as if we have opened a door or a curtain, represented by a black band along the right edge of the canvas, in order to expose the artist. A harsh light floods the space, accentuating his hard form and unyielding personality. In contrast, Sherman's figure is nearly eclipsed by a soft, dark ambiance. The dramatic illumination, borrowed from Baroque painting, infiltrates her private space and, highlighting only a few areas of her body, her face, and her bleached hair, offsets the mannerism of her pose. While Beckmann's reaction to our intrusion is rigid and confrontational, Sherman has seemingly been caught unaware, and she remains vulnerable.

Beckmann's life and art were ineluctably shaped by his being a German during the first half of the twentieth century; Sherman's are inextricably bound by her being a woman in the second half. As she has said, "Everything in [my work] was drawn from my observations as a woman in this culture. And part of that is a love-hate thing—being infatuated with make-up and glamour and detesting it at the same time. It comes from trying to look like a proper young lady or look as sexy or as beautiful as you can make yourself, and also feeling like a prisoner of that structure."[3] The leitmotif of disguise and masking that permeates the work of these two artists is a reflection of this distrust for appearances and the sense of freedom denied. Imprisoned within their metaphorically tight, boxlike spaces, these figures respond to the social and psychological restrictions that have shaped them with gestures of sardonic disillusionment.

1. Max Beckmann, "On My Painting," lecture delivered in London, July 21, 1938, translated in *Max Beckmann Self-Portrait in Words: Collected Writings and Statements, 1903–1950* (Chicago and London: University of Chicago Press, 1997), p. 302.

2. Beckmann volunteered for the German army medical corps in 1914. By July 1915 his idealistic attitude toward the war had changed, and he suffered a nervous collapse and was discharged from military service.

3. Cindy Sherman, interviewed by Noriko Fuku, "A Woman of Parts," *Art in America* 85, no. 6 (June 1997): 80.

MAX BECKMANN
Self-Portrait with a Cigarette. 1923.
Oil on canvas, 23 x 15⁷/₈" (60.2 x 40.3 cm).
The Museum of Modern Art, New York.
Gift of Dr. and Mrs. F. H. Hirschland

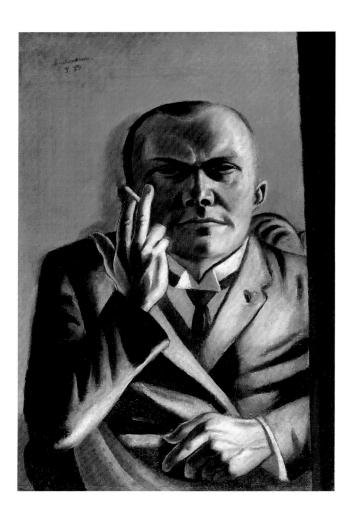

CINDY SHERMAN
Untitled #113. 1982.
Chromogenic color print, 44$^5/_{16}$ x 29$^1/_2$" (112.5 x
74.9 cm). The Museum of Modern Art, New York.
Gift of Werner and Elaine Dannheisser

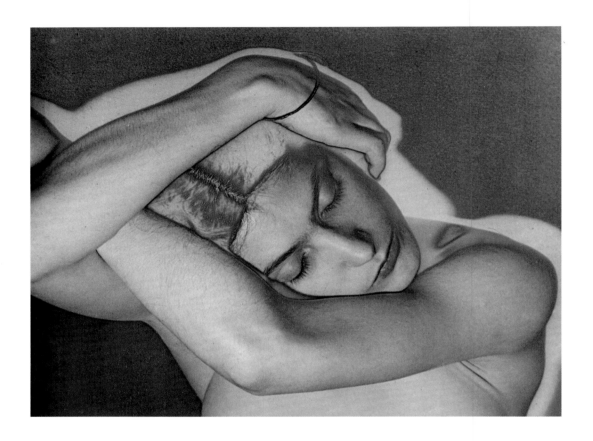

MAN RAY
Sleeping Woman. 1929.
Solarized gelatin silver print, 6 $\frac{1}{2}$ x 8 $\frac{1}{2}$" (16.5 x
21.6 cm). The Museum of Modern Art, New York.
Gift of James Thrall Soby

PABLO PICASSO
Repose. 1908.
Oil on canvas, 32 x 25¹/₄" (81.2 x 65.4 cm).
The Museum of Modern Art, New York. Acquired
by exchange through the Katherine S. Dreier Bequest
and the Hillman Periodicals, Philip Johnson, Miss
Janice Loeb, Abby Aldrich Rockefeller, and Mr. and
Mrs. Norbert Schimmel Funds

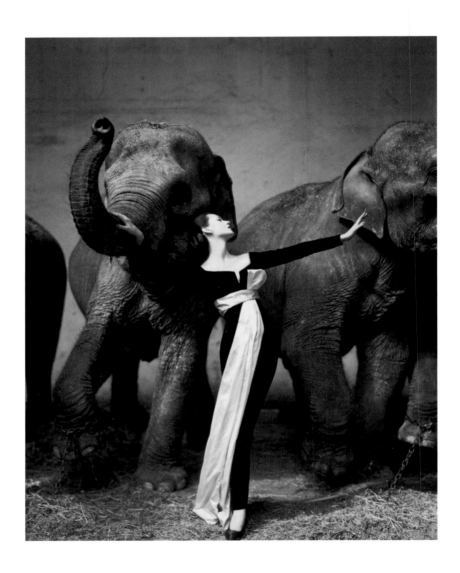

RICHARD AVEDON
Dovima with Elephants, Evening Dress by Dior,
Cirque d'Hiver, Paris. August 1955.
Gelatin silver print, 19¹/₁₆ x 15¹⁵/₁₆" (48.4 x 38.2 cm).
The Museum of Modern Art, New York. Gift of the
photographer. ©1955 Richard Avedon

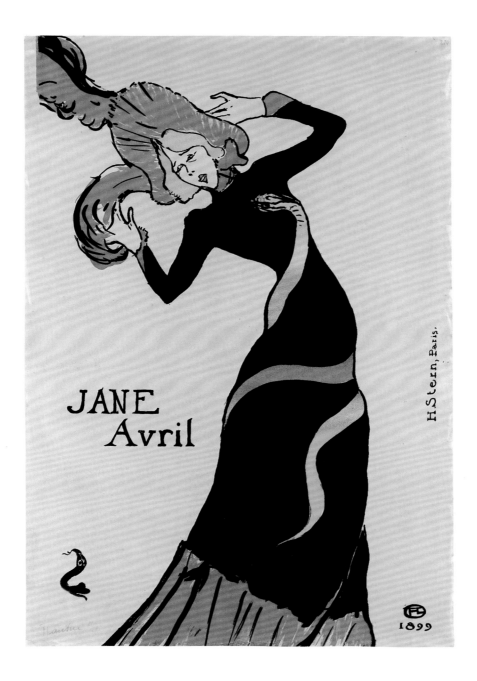

HENRI DE TOULOUSE-LAUTREC
Jane Avril. 1899.
Lithograph, comp.: 22$^1/_{16}$ x 14$^1/_{16}$" (56 x 35.7 cm).
Publisher: Jane Avril. Printer: H. Stern, Paris. Signed
edition: 25. The Museum of Modern Art, New York.
Gift of Abby Aldrich Rockefeller

W. K.-L. DICKSON
Sandow. 1894.
35mm, black and white, silent, 30 seconds
(approx.). The Museum of Modern Art, New York.
Henry Ford Museum and Greenfield Village,
Dearborn, Michigan (by exchange)

EGON SCHIELE
Nude with Arm Raised. 1910.
Watercolor and charcoal on paper, 17¹/₂ x 12¹/₄"
(44.5 x 30.8 cm). The Museum of Modern Art,
New York. Gift of Ronald S. Lauder

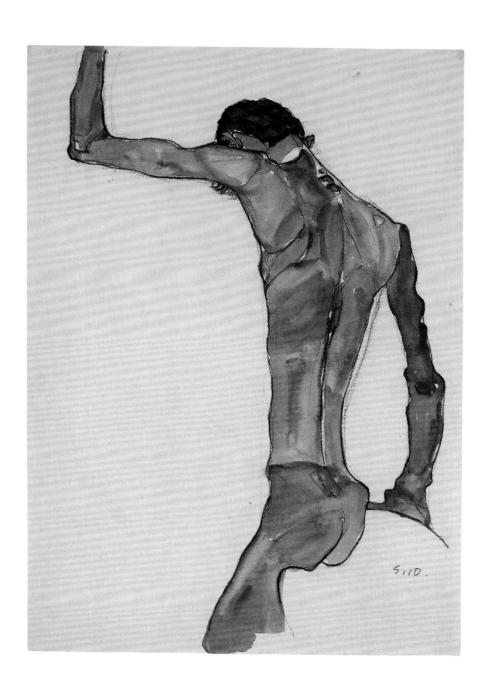

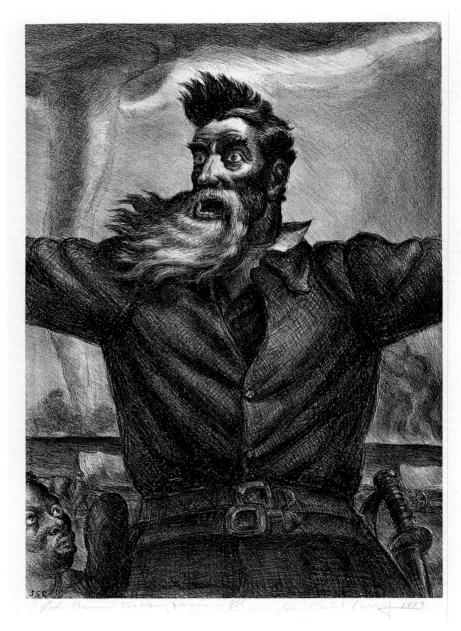

JOHN STEUART CURRY
John Brown. 1939, published 1940.
Lithograph, comp.: 14³/₈ x 10¹/₁₆" (36.6 x 25.6 cm).
Publisher: Associated American Artists, New York.
Printer: George Miller, New York. Edition: 250.
The Museum of Modern Art, New York. Abby
Aldrich Rockefeller Fund (by exchange)

ARNULF RAINER
Self-Portrait. c. 1975.
Photogravure with etching and drypoint, plate:
11¹/₁₆ x 12¹/₂" (28.1 x 31.7 cm). Printer: Kurt Zein,
Vienna. Edition: unknown. The Museum of Modern
Art, New York. Larry Aldrich Fund

Käthe Kollwitz, *Help Russia*
Dorothea Lange, *Just About to Step into the Bus for the Assembly Center, San Francisco*

Starr Figura

Käthe Kollwitz's *Help Russia* and Dorothea Lange's *Just About to Step into the Bus for the Assembly Center, San Francisco* were created by artists working at different times and in separate places, using particular mediums under distinct circumstances (pp. 56–57). Yet these works share certain essential characteristics, most notably the motif of hands surrounding a central figure to dramatically illustrate that figure's helplessness or persecution.

Kollwitz, who lived through a period of great social and economic upheaval in Germany, including two World Wars, had an overriding compassion for the poor and the powerless, and she devoted her art and her life to moral and social betterment. *Help Russia* was produced in response to a drought in the Volga Basin that led to widespread famine in the then-struggling new nation of the Soviet Union.[1] It was one of several lithographic posters that Kollwitz made during the years following the end of World War I to draw attention to the victims of postwar political and economic instability. Copies of the print were offered all over Germany, and the funds collected from their sale were used for the relief efforts in Russia. In 1922 Kollwitz wrote, "I am content that my work should have purposes outside itself. I would like to exert influence in these times when human beings are so perplexed and in need of help."[2]

Lange was also a passionate idealist who strove in her work to ameliorate the social turmoil in the United States caused by the Great Depression and World War II. She is most famous for her photographs for the Farm Security Administration (FSA), which was established by President Franklin D. Roosevelt in 1935 to educate the public about the severe effects of the Depression and to demonstrate the steps the government was taking to alleviate poverty and suffering. *Just About to Step into the Bus* is from a slightly later series, when Lange was working for the War Relocation Authority (WRA), another New Deal era agency. Instituted in March 1942, shortly after the 1941 bombing of Pearl Harbor, the WRA oversaw the internment, or "relocation," of some 110,000 Japanese-Americans, most of them living on the West Coast. Like the FSA, the WRA viewed photography as a means of disseminating favorable images of its activities to the public. Both agencies made Lange's photographs widely available for reproduction in newspapers and magazines.

Most of Lange's WRA photographs, including this one, depict Japanese-Americans on the eve of their incarceration. They reveal the process by which innocent citizens were rounded up and sent to holding pens, called "assembly centers." Lange recognized the inhumanity in this, and she used her photographs to subtly convey her disapproval. Her works show Japanese-Americans, many of whom were immigrants or first-generation Americans, as

people who had achieved a measure of success through their hard work and perseverance and who maintained dignity in the face of injustice and humiliation.

As women artists concerned with the social and political issues of their times, Kollwitz and Lange utilized two mediums that are often, perhaps unfairly, considered the minor arts: printmaking and photography. Both are reproductive mediums, meaning that the plate or negative can be printed more than once to produce multiple copies of an image that can then be widely disseminated. This populist approach to subject matter and medium also extended to the style of their imagery. While many of Kollwitz's peers, especially the German Expressionists, were experimenting with formal innovations, her own style remained conservative and dependent on the kind of resolute realism and bold, graphic expression that could most easily be understood by a mass audience. Lange's earnest images came to be identified with the term "documentary photography"—photography that is not self-consciously artistic but instead a tool of social advocacy marked by a style that is meant to look ingenuous and authentic.

Both pictures rely on the representation of gesture to put forward a pleading or pointed commentary on the human condition. Yet this representation is somewhat unusual because the most significant action is expressed not by the central figure, but, rather, by anonymous hands projecting toward this figure from outside the picture frame. It may not be initially obvious which set of hands is meant to support and which to oppress—the hands in the Kollwitz print appear rough and uninviting, while the intruding hands in Lange's photograph look soft and gentle. But there are other pictorial references and details that help to clarify the messages in these works. For example, Kollwitz presents us with an emaciated figure whose slumped, defeated posture and agonized, half-dead expression recall representations of the suffering and death of Christ. The surrounding hands may invoke those of Christ's followers removing him from the cross.

The telling details that help place Lange's photograph within the historical moment it represents include: a crowd of other detainees waiting anxiously behind the central character; what appears to be an official form at the lower left; and, attached to the central figure's lapel, an identification tag that serves to dehumanize and humiliate him. Like Kollwitz, Lange uses her protagonist's body language to expressive and symbolic effect. His downcast eyes and passive demeanor suggest submission. The offending hands, detached from individual identity, approach and touch him with a sense of entitlement that is inappropriately proprietary. These anonymous hands, belonging at once to no one and to everyone, suggest a pattern of mass blame and a lack of individual accountability that Lange means to criticize. Kollwitz and Lange fervently and eloquently remind us that it is our actions, the gestures we make as individuals, that define us as a society.

1. On the first state of the print, the words "Helft Russland" appeared across the top. For the second and third states, the text was removed.

2. Käthe Kollwitz diary entry, November 1922, translated in Hans Kollwitz, ed., *The Diary and Letters of Kaethe Kollwitz* (Evanston, Ill.: Northwestern University Press, 1988), p. 104.

Käthe Kollwitz
Help Russia (Helft Russland). 1921.
Lithograph, comp.: 16 1/8 x 18 11/16" (41 x 47.5 cm).
Publisher: Komite für Arbeiterhilfe, Berlin. Printer:
Hermann Birkenholz, Berlin. Edition, third state: 300.
The Museum of Modern Art, New York. The Ralph E.
Shikes Fund

Dorothea Lange
*Just About to Step into the Bus for the Assembly
Center, San Francisco*. 1942.
Gelatin silver print, printed later, 9¹/₂ x 9³/₈"
(24.1 x 23.8 cm). The Museum of Modern Art,
New York. Purchase

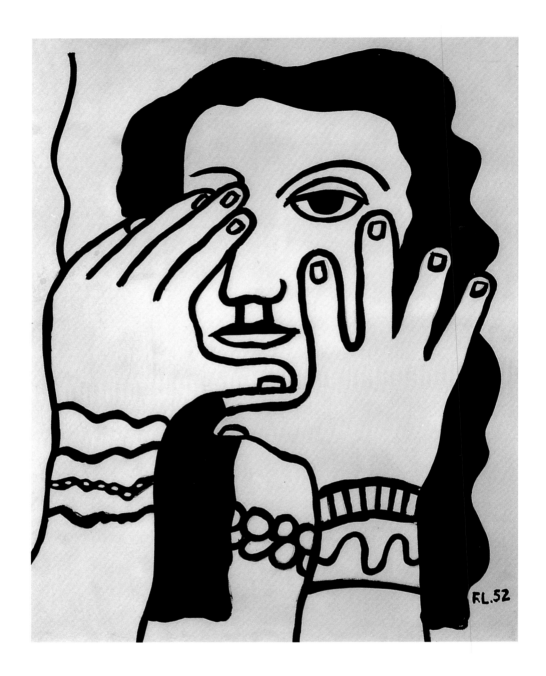

FERNAND LÉGER
Face and Hands. 1952.
Brush and ink, and pencil on paper, 26 x 19³/₄"
(66 x 50.1 cm). The Museum of Modern Art,
New York. Mrs. Wendell T. Bush Fund

Luis Buñuel
Un Chien andalou. 1928.
35mm, black and white, silent, 17 minutes (approx.).
The Museum of Modern Art, New York. Gift of
the artist

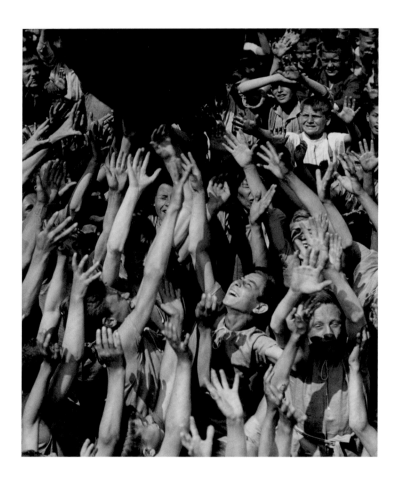

Martin Munkacsi
Vacation Fun. 1929.
Gelatin silver print, 13⁵/₁₆ x 10³/₄" (33.7 x 27.3 cm).
The Museum of Modern Art, New York. Purchased
as the gift of Lois and Bruce Zenkel

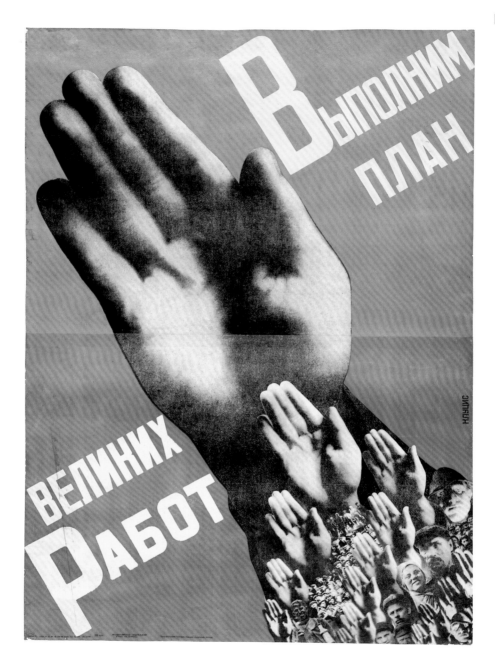

GUSTAV KLUCIS
Fulfilled Plan, Great Work. 1930.
Gravure, 46 3/4 x 33 1/4" (118.8 x 84.4 cm).
The Museum of Modern Art, New York.
Purchase Fund, Jan Tschichold Collection

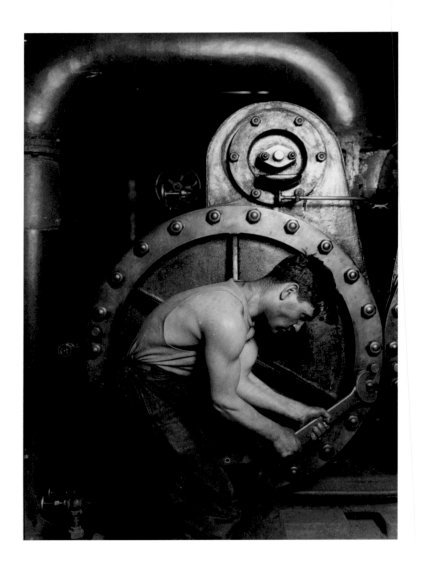

LEWIS W. HINE
Steamfitter. 1920.
Gelatin silver print, 9⁵/₈ x 6¹⁵/₁₆" (24.4 x 17.6 cm).
The Museum of Modern Art, New York. Purchase

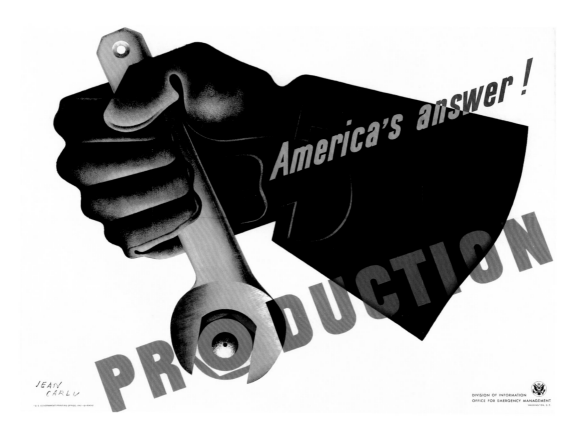

Jean Carlu
America's Answer—Production. 1942.
Offset lithograph, 29⁷/₈ x 39⁵/₈" (75.9 x 100.7 cm).
The Museum of Modern Art, New York. Gift of the
Office for Emergency Management

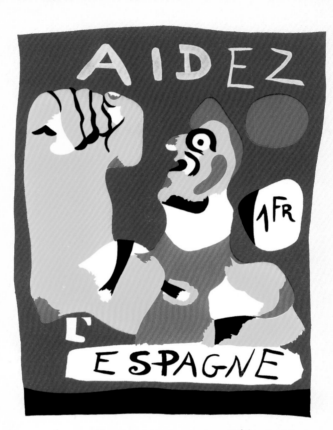

JOAN MIRÓ
*Help Spain (**Aidez l'Espagne**)*. 1937.
Pochoir, comp.: 9³/₄ x 7⁵/₈" (24.8 x 19.4 cm).
Publisher: Éditions Cahiers d'Art, Paris. Printer:
Moderne Imprimerie, Paris. The Museum of
Modern Art, New York. Gift of Pierre Matisse

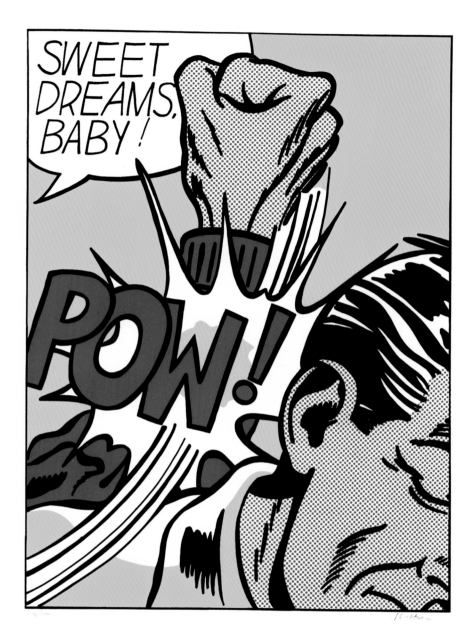

ROY LICHTENSTEIN
**Sweet Dreams, Baby! from the portfolio 11 Pop
Artists, volume III**. 1965, published 1966.
Screenprint, comp.: 35⅝ x 25⁹/₁₆" (90.5 x 64.9 cm).
Publisher: Original Editions, New York. Printer:
Knickerbocker Machine and Foundry Inc., New York.
Edition: 200. The Museum of Modern Art, New York.
Gift of Original Editions

POSTURE

Henri Matisse, *Bather*
Umberto Boccioni, *Unique Forms of Continuity in Space*

Sarah Ganz

The posture of a depicted body enlivens an image in its ability to communicate narrative, disposition, and progression of time. Body posture intimates a world beyond and outside the frame of a stilled image while also potentially revealing the subject's character and inner state of being. Posture lends expression or speech to a form of art which otherwise, as Ernst Gombrich stated, is "only lacking voice . . . embodying everything of real life except speech."[1]

In Henri Matisse's *Bather* of 1909 (p. 70), the solid pink figure inscribed by bold black contours fills the picture, its torso bent forward as it wades through the water away from the viewer. Executed in preparation for Sergei Shchukin's commission of large decorative panels for the staircase of his Moscow home, *Bather* was probably rendered from memory rather than from life and is generally based on a figure in Paul Cézanne's *Three Bathers*, of about 1879–82, which Matisse owned. The ambiguity of the figure's gender—its short hair, stocky body, and fleshy uncertain appendage, which may be a concealed breast—recalls Cézanne's Bathers. This reference is accentuated by the abstract space in which the figure is situated: a uniform blue field interrupted only by the suggestion of rippling and splashing turquoise water. The nude body is rendered so economically—its legs truncated by the canvas edge, its arms redrawn and shifting, placed in an indeterminate space that is equally the water's surface and a vertical backdrop of blue—that, as a result, all we are left with to decipher the image is the posture of the body itself.

Matisse, through his reading of the aesthetician and philosopher Henri Bergson, was deeply interested in the question of how time could be represented in painting and the manner in which time intersected with the space of the painting. Matisse's *Bather* may be read as an illustration of Bergsonian notions: "Discontinuous though they may appear [separated temporal incidents] stand out against the continuity of a background on which they are designed, and to which they owe the intervals that separate them."[2] In the articulation of movement through pose and multiple contours, we are given a sense of the duration of time, a progression of successive moments. Represented in the process of transition from one pose to another, the body functions as a vehicle of experience and insight rather than solely as an object of contemplation. Bergson heralded the body as the center of perception: "As my body moves in space, all the other images vary, while that image, my body remains invariable. I must therefore, make it a center, to which I refer all the other images . . . *My* body is that which stands out at the center of these perceptions."[3] Similarly, Matisse emphasized the body as a means through which essential qualities can be perceived, as he stated in 1908: "What interests me most is neither still life nor

landscape, but the human figure. . . . I do not insist upon all the details of the face . . . I . . . discover his essential qualities . . . A work of art must carry within itself its complete significance and impose that upon the beholder even before he recognizes the subject matter."[4] Matisse's *Bather* achieves just this—the significance of the body is understood through its posture, which one reads before discerning context and subject matter.

It is the posture of Matisse's *Bather,* bent forward with weighted strides, that allows us to read the abstract environment as water. With Umberto Boccioni's *Unique Forms of Continuity in Space* of 1913 (p. 71) body and environment interpenetrate. The figure steps forth, its center of gravity thrust forward, while contours of flesh are shaped by and dissolve into the air through which the body moves. Boccioni called for a sculpture of environment in his "Technical Manifesto of Futurist Painting" of 1910, stating that "the gesture which we would reproduce on canvas shall no longer be a fixed *moment* in universal dynamism. It shall be the dynamic sensation itself. . . . We therefore cast aside and proclaim the absolute and complete abolition of definite lines and closed sculpture. We break open the figure and enclose it in environment."[5] The confluence of metal, flesh, and air presents a figure at once ensconced in fluttering flames and weighted down by the heavy blocks on which it stands as well as the apparent effort required to penetrate the space through which it moves.

The voice of Bergson permeates Boccioni's ideas and those of the Futurist manifestos; the application of philosophical inquiry to the body particularly attracted the Italian artist, as it had Matisse. *Unique Forms of Continuity in Space* seems to materialize Bergson's claims for the body as the vehicle through which space and environment are perceived: "Consider the movement of an object in space. My perception of the motion will vary with point of view . . . but when I speak of an absolute movement, I am attributing to the moving object an inner life and so to speak, states of mind."[6] The glistening bronze figure suggests progress through time and space; its undulating contours, like the black lines of the *Bather*'s redrawn arm, intimate mobility and duration beyond the represented moment. Although the figure was born of aspirations toward modernity and dynamism, its armless, sexless appearance is evocative of antiquity, including the winged *Victory of Samothrace.*

In these works, posture is conditioned by environment, the direct relation of the body to nature. The representation of the single figure taking a step forward has a lineage in the history of art, evoking archetypal Egyptian striding figures and Archaic and early Classical *kourai*, a convention which signifies going forth. This arrangement of the body also vividly recalls late-nineteenth-century experiments in photography by Étienne-Jules Marey and Eadweard Muybridge which fragmented the repetitive motion of a figure walking into distinct increments of movement.

1. Ernst H. Gombrich, "Action and Expression in Western Art (1970)," in *The Image and The Eye* (London: Phaidon Press, 1994), p. 78.
2. Henri Bergson, *Creative Evolution* (1911), trans. Arthur Mitchell (New York: Modern Library, 1944), p. 5.
3. Henri Bergson, *Matter and Memory* (1896), trans. Nancy M. Paul and W. Scott Palmer (New York: Zone Books, 1988), pp. 46–47.
4. Henri Matisse, "Notes of a Painter, 1908," in Jack D. Flam, ed., *Matisse on Art* (New York: E. P. Dutton, 1978), p. 38.
5. Umberto Boccioni, "Technical Manifesto of Futurist Painting," in Charles Harrison and Paul Wood, eds., *Art in Theory, 1900–1990: An Anthology of Changing Ideas* (Oxford: Blackwell, 1992), p. 124.
6. Henri Bergson, *An Introduction to Metaphysics*, trans. T. H. Hume (London: Macmillan, 1913), pp. 1–2.

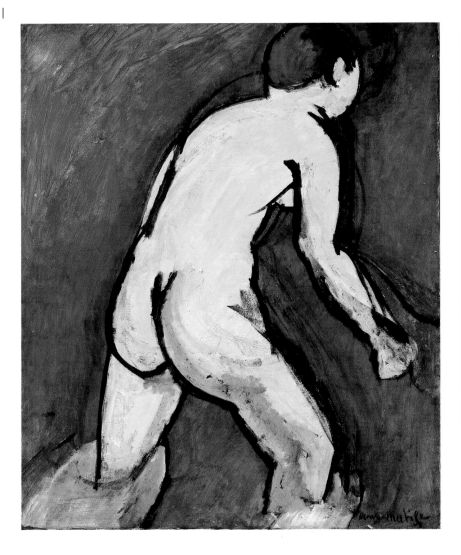

HENRI MATISSE
Bather. 1909.
Oil on canvas, 36 $^{1}/_{2}$ x 29 $^{1}/_{8}$" (92.7 x 74 cm).
The Museum of Modern Art, New York. Gift of
Abby Aldrich Rockefeller

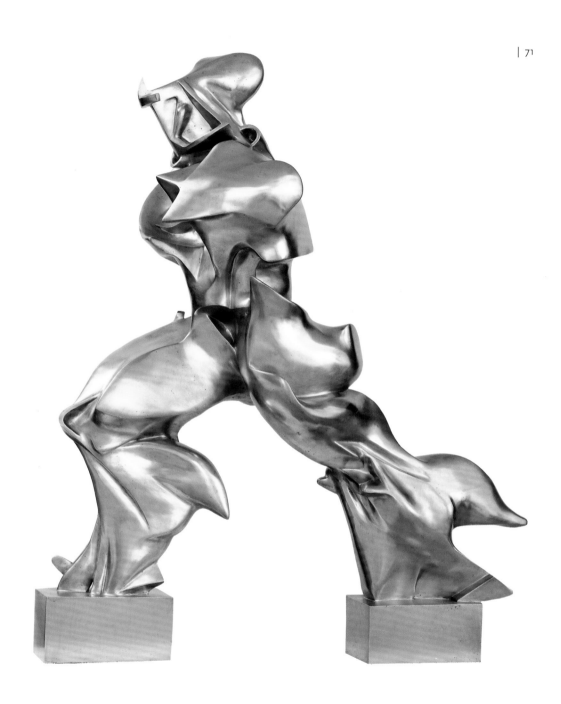

UMBERTO BOCCIONI
Unique Forms of Continuity in Space. 1913.
Bronze (cast 1931), 43$^{7}/_{8}$ x 34$^{7}/_{8}$ x 15$^{3}/_{4}$" (111.2 x
88.5 x 40 cm). The Museum of Modern Art, New
York. Acquired through the Lillie P. Bliss Bequest

Auguste Rodin
Nijinsky. c. 1912.
Bronze (cast 1958), 7$^1/_4$ x 2$^1/_4$ x 3$^1/_2$" (18.4 x 5.7 x 8.9 cm). The Museum of Modern Art, New York. Louise Reinhardt Smith Bequest

ERNEST J. BELLOCQ
Untitled. c. 1912.
Gelatin silver printing-out-paper print by Lee
Friedlander from the original negative, c. 1966–69,
9¹³/₁₆ x 7¹³/₁₆" (25.4 x 20.2 cm). The Museum of
Modern Art, New York. Gift of Lee Friedlander

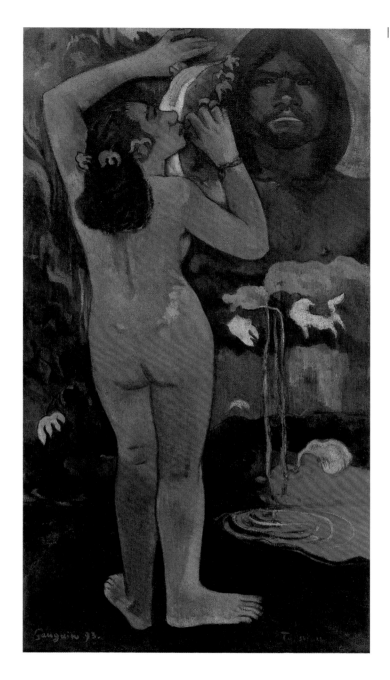

PAUL GAUGUIN
The Moon and The Earth (Hina Tefatou). 1893.
Oil on burlap, 45 x 24^1/$_2$" (114.3 x 62.2 cm).
The Museum of Modern Art, New York. Lillie P.
Bliss Collection

PAUL GAUGUIN
Watched by the Spirit of the Dead (Manao Tupapau)
from the series Noa Noa. 1893–94, reprinted 1921.
Woodcut, plate: 8 ¹/₁₆ x 14" (20.5 x 35.5 cm). Publisher
and printer: Pola Gauguin, Copenhagen. Edition:
100. The Museum of Modern Art, New York. Lillie P.
Bliss Collection

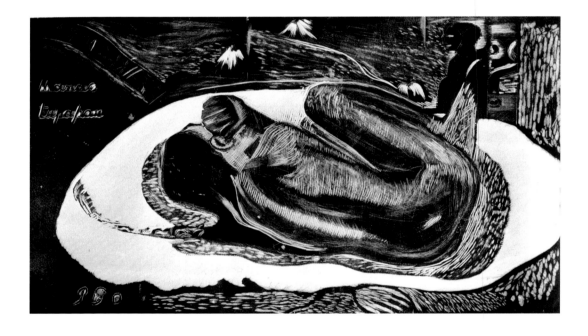

ARISTIDE MAILLOL
Crouching Woman. 1930.
Bronze, 6³/₈ x 9³/₈ x 4³/₄" (16.2 x 23.8 x 12.1 cm).
The Museum of Modern Art, New York. Louise
Reinhardt Smith Bequest

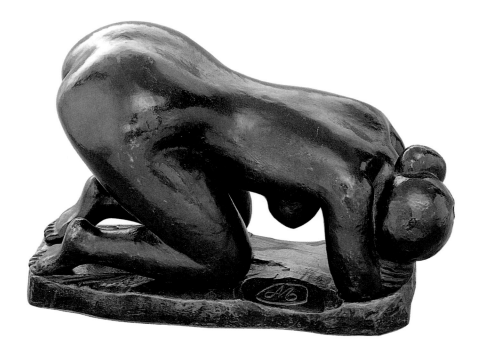

DOROTHEA LANGE
Street Demonstration, San Francisco. 1933.
Gelatin silver print, 17⁷/₁₆ x 13" (44.4 x 33 cm).
The Museum of Modern Art, New York. Purchase

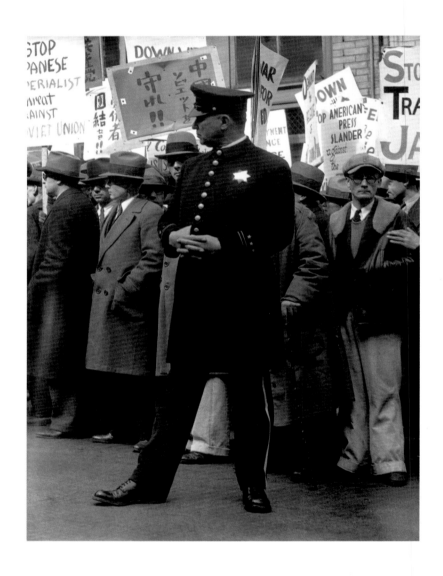

AUGUSTE RODIN
Naked Balzac with Folded Arms. 1892.
Bronze (cast 1966), 29 x 12¹/₈ x 13⁵/₈" (75.5 x 30.8 x
34.6 cm). The Museum of Modern Art, New York.
Gift of the B. G. Cantor Art Foundation

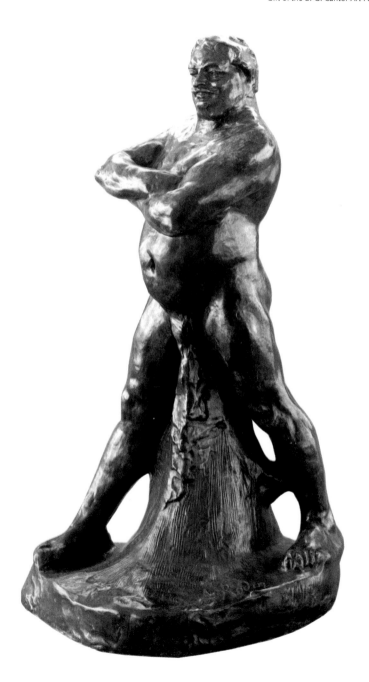

Henri de Toulouse-Lautrec, *M. de Lauradour*
Louise Dahl-Wolfe, *Nashville*

Sarah Ganz

A man in black jacket and top hat relaxes into a wicker chair, legs crossed and hands resting gracefully on his lap as he smokes a pipe. His bristling red hair and beard in part inspired Henri de Toulouse-Lautrec to make this 1897 portrait of M. de Lauradour (p. 83). The sitter's gaze is directed toward a bed on which lie, suggestively, a pair of woman's shoes, indicating that he is in a brothel (actually staged in the artist's studio). He is a dandy in demeanor and deportment; his body is placed parallel to the picture plane, pressed close to its surface, inviting our inspection of his posture and physiognomy. Another man assumes the same posture in Louise Dahl-Wolfe's photograph *Nashville* (p. 82), this time in an abandoned and worn theater. This resident of the Tennessee Great Smoky Mountains slouches into a front row seat, legs crossed and hands in his lap, his head cocked forward and his gaze directed off to the left.

Toulouse-Lautrec painted his portrait of M. de Lauradour during a period in the artist's oeuvre when he was fascinated by body type and physiognomy as a vehicle of psychological investigation, often seeking out subjects with strong physical characteristics and peculiar faces. This interest stems directly from Lautrec's profound admiration for Edgar Degas, whose realist project coincided with, and was in part fueled by, the especially popular development of physiognomics. This pseudo-science was founded on the belief that the human form, along with costume and environment, could be read as a text, unmasking a subject's inner state, social class, and métier. Edmund Duranty's "The New Painting," a 1876 review of the second Impressionist Exhibition, celebrates Degas's technique of isolating components that disclose everything about the whole: "By means of a back, we want a temperament, an age, a social condition to be revealed; through a pair of hands, we should be able to express a magistrate or a tradesman; by a gesture, a whole series of feelings. A physiognomy will tell us that this fellow is certainly an orderly, dry, meticulous man, whereas that one is carelessness and disorderliness itself."[1] In a carefully contrived casualness, Lautrec achieves intimacy and immediacy that permits the viewer to discern temperament, age, and social condition through the rendering of M. de Lauradour's back, hands, and gesture. His easy casualness, disinterested look, and impeccable attire show him to be a man of wealth, leisure, and perhaps easily given to insolence.[2] It was the distinctive, telling demeanor of the sitter that prompted the artist to construct a composition to frame and accentuate the subject's posture, which becomes, in this painting, a window into his social and psychological state.

Dahl-Wolfe's image belongs to a series of photographs, taken during the Depression, of Tennessee mountain folk. *Nashville* falls early in Dahl-Wolfe's

career as a photographer; she went on to revolutionize the scope of fashion photography in later years. In many respects Dahl-Wolfe carries on Duranty's challenge to artists issued almost half a century earlier. The sitter's retiring posture and threadbare attire intimate the oppression of his social class. As in Lautrec's portrait, the subject appears close to the picture plane, on offer for our inspection. Although it was the natural deportment of this man that initially attracted the artist, his telling posture is accentuated by the photographer's decision to place her camera above, looking down on him. Despite the fact that body posture is similar in these images, the meaning derived from the arrangement of the body differs in its details: Dahl-Wolfe's subject is more hunched over, his clothes more ragged, his gaze more insecure and questioning, his setting not one of masculine privilege, but of emptiness and isolation.

Our ability to read these postures actually exists independently of how they are registered by the artist in painting or photograph. In his discussion on pose in "The Photographic Message," Roland Barthes states: "The actual pose of the subject prepares the reading of the signfieds of connotation: the photography signifies . . . only because there exists a stock of stereotyped attitude which constitute ready-made elements of signification."[3] In other words, what makes posture legible in an image depends primarily on the fact that it is socially and culturally inscribed. The viewer draws upon "a 'historical grammar' of iconographic connotation."[4] It is an understanding of body language that permits posture to be read, and the manner in which a body is represented in an image serves to temper and explicate a specific reading of the depicted figure.

These images are not only portraits of two men, but studies of their milieus. Their bodies' interaction with their given environments aids in our understanding of them. These representations do not conform to the conventions of portrait postures, which traditionally implied decorum and morality in favor of the seemingly candid, relaxed, and contextual.[5] This violation of the expectations of portraiture—a man alone in a dilapidated theater, or in a brothel instead of a more elevating locale—beguiles us into thinking that we are privy to that reality of the sitter's life. This is due in part to the fact that the body is often perceived as expressive of some inner, pre-linguistic emotional state and therefore body language is thought to reveal some truth about its source of expression. As one sociologist has articulated this: "While we think that speech as an examplar of language and culture can cover over the 'real' attitude of the speaker, body movement, it is thought, does not; it reveals it."[6] Therefore, a reading of posture lends speech to the work of art.

1. Edmund Duranty, "The New Painting: concerning the Group of Artists exhibiting at the Durand-Ruel Galleries (1876)," in Linda Nochlin, ed., *Impressionism and Post-Impressionism, 1874–1904, Sources and Documents* (Englewood Cliffs, N. J.: Prentice-Hall, 1966), p. 5.
2. There is very little known of M. de Lauradour despite this portrait and an encounter that Lautrec witnessed in which Lauradour physically assaulted a man on the street who had insulted him. See Henri Perruchot, *Toulouse-Lautrec,* trans. Humphrey Hare (Cleveland and New York: Wold Publishing, 1960), p. 234.
3. Roland Barthes, "The Photographic Message," in *The Responsibility of Forms,* trans. Richard Howard (Berkeley: University of California Press, 1991), p. 10.
4. Ibid.
5. Linda Nochlin, "Impressionist Portraits and the Construction of Modern Identity," in Colin B. Bailey, *Renoir's Portraits: Impressions of an Age* (New Haven and London: Yale University Press, 1997), pp. 53–75.
6. Helen Thomas, *Dance, Modernity and Culture: Explorations in the Sociology of Dance* (London and New York: Routledge, 1995), pp. 6–7.

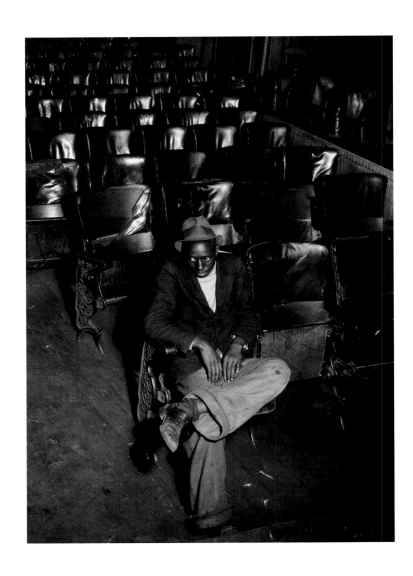

LOUISE DAHL-WOLFE
Nashville. 1932.
Gelatin silver print, 12⁷/₈ x 9¹/₈" (32.7 x 23.1 cm).
The Museum of Modern Art, New York. Gift of the
photographer

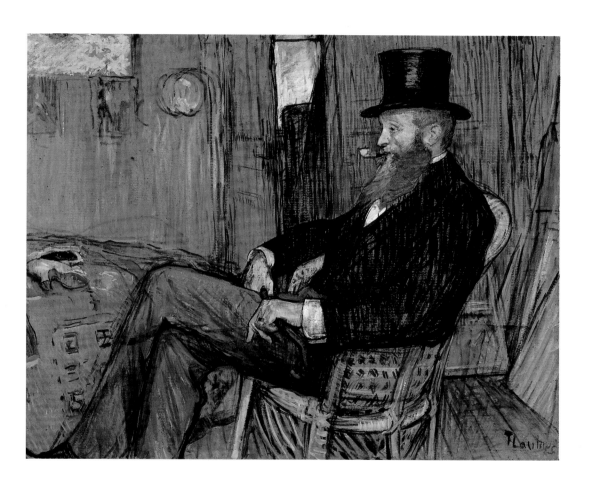

Henri de Toulouse-Lautrec
M. de Lauradour. 1897.
Oil and gouache on cardboard, 26³/₄ x 32¹/₂" (68 x
82.5 cm). The Museum of Modern Art, New York.
The William S. Paley Collection

WILLARD VAN DYKE
Ansel Adams at 683 Brockhurst, San Francisco. 1932.
Gelatin silver print, 9⁵/₁₆ x 7¹/₄" (23.6 x 18.4 cm).
The Museum of Modern Art, New York. Gift of the
photographer

PAUL GAUGUIN
Portrait of Jacob Meyer de Haan. 1889.
Watercolor and pencil on paper, 6 ³/₈ x 4 ¹/₂" (16.4 x
11.5 cm). The Museum of Modern Art, New York.
Gift of Arthur G. Altschul

GEORGE PLATT LYNES
Lincoln Kirstein. c. 1940.
Gelatin silver print, $9^{5}/_{16}$ x $7^{1}/_{4}$" (23.6 x 18.4 cm).
The Museum of Modern Art, New York. Gift of
Russell Lynes

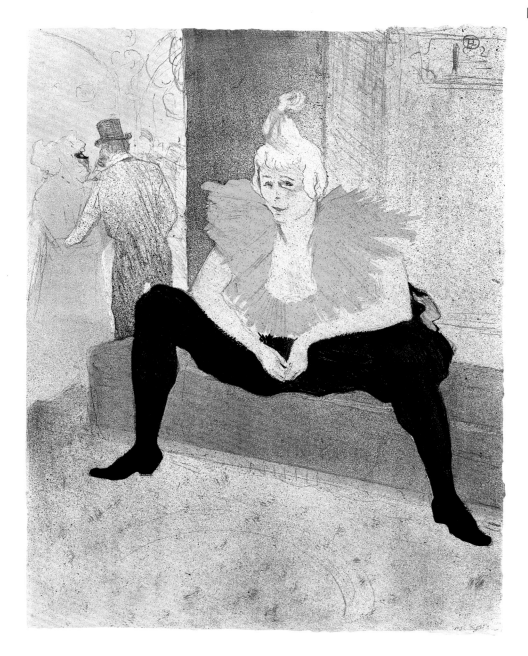

HENRI DE TOULOUSE-LAUTREC
The Seated Clowness from the portfolio *Elles*. 1896.
Lithograph, sheet: 20⁷/₈ x 15⁷/₈" (53 x 40.3 cm).
Publisher: Éditions Pellet, Paris. Printer: Auguste
Clot, Paris. Edition: 100. The Museum of Modern
Art, New York. Gift of Abby Aldrich Rockefeller

AUGUSTE RODIN
Study for *The Gates of Hell*. c. 1900–08.
Watercolor and pencil on paper, 13 x 9³/₄" (33 x
24.9 cm). The Museum of Modern Art, New York.
Bequest of Mina Turner

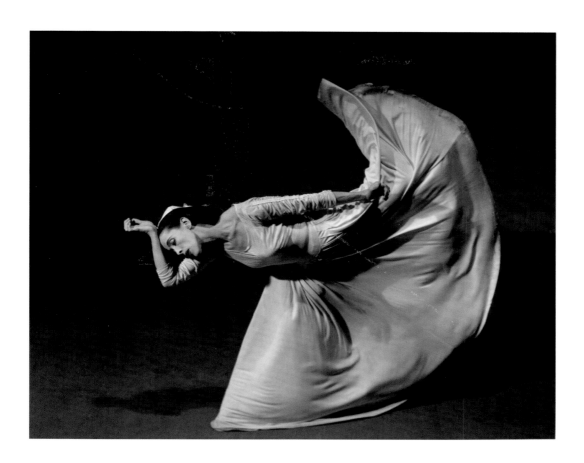

BARBARA MORGAN
Martha Graham—Letter to the World (Kick). 1940.
Gelatin silver print, 14 x 18 ³/₈" (37.4 x 46.7 cm).
The Museum of Modern Art, New York. John
Spencer Fund. ©Barbara Morgan, 1940

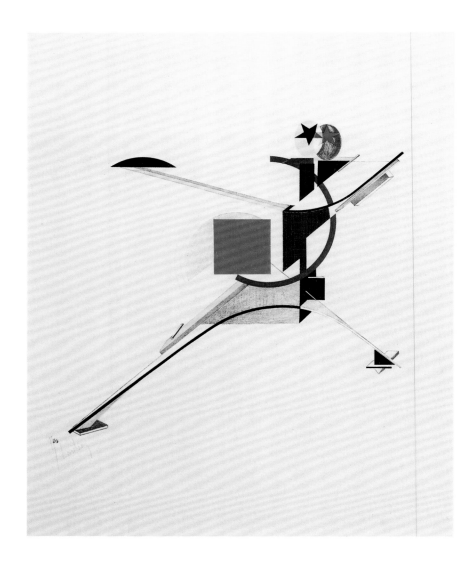

EL LISSITZKY
The New One from the portfolio **Figurines, Plastic representation of the electro-mechanical production entitled "Victory over the Sun."** 1920–21, published 1923.
Lithograph, sheet: 21 x 17¹³/₁₆" (53.3 x 45.4 cm).
Printer: Robert Leunis & Chapman, Hannover.
Edition: 75. The Museum of Modern Art, New York. Purchase

Oskar Schlemmer
Study for _The Triadic Ballet_. c. 1921–23.
Gouache, brush and ink, incised enamel, and cut-
and-pasted photographs on paper, 22⅝ x 14⅝"
(57.5 x 37.1 cm). The Museum of Modern Art,
New York. Gift of Lily Auchincloss

PAIRS

ÉDOUARD VUILLARD, *Mother and Sister of the Artist*
SEYDOU KEÏTA, *Bamako*

Maria del Carmen
González

Édouard Vuillard is often called an "intimist" painter, a description that seems to fit perfectly his rendering of *Mother and Sister of the Artist*, given its small size and delicacy of handling, and the circumscribed interior view that presents an intimate, domestic scene (p. 96). Yet, the painting is not the modest, unassuming work it may at first seem to be.

Painted in 1893, it shows Vuillard's mother, born Marie Michaud, the daughter of a Parisian textile designer and manufacturer, sitting next to her only daughter, also called Marie. His sister was seven years older than Vuillard, and the year the picture was painted, she married his fellow artist and friend, Ker-Xavier Roussel. Up to this point, she had worked for her mother, who, although widowed at an early age, built up a dressmaking business within the home.

The family portrait is a traditional subject, and often a very revealing one. In this painting, family tension is implied. The daughter bends in a supplicant position. (If she were to stand, her head would be cropped off by the top edge of the painting.) The room appears to close in on her. The gridded textile of her dress merges with the speckled patterning of the wallpaper, causing her to dissolve into the wall, seeming merely part of the wallpaper—or, at best, a fragile, wraithlike apparition, floating in the space of the picture, clutching the wall for support, a subordinate figure to the bulk of her seated mother.

The aggressive posture of her mother, legs spread apart beneath an unrevealing dress, her feet planted firmly on the ground, seems almost a subversion of femininity at the service of maternal power. The sheer blackness of the figure's dress draws the viewer's attention to it; one is also struck by the solidity of her form and the stark contrast of her pale face and gnarled hands. Beside her are the remnants of a meal: an almost empty plate, a wine bottle, and a napkin strewn at the edge of the table. Surely, a message is to be drawn from this. The arrangement of the two figures and their setting tell a story, and the artist's technical means both support and disguise the story.

In Seydou Keïta's *Bamako* of 1956–57 a quite different familial situation is shown (p. 97). A young girl, her legs slightly apart and her barely visible right arm drawn tightly next to her body, looks directly at the camera. She wears a multipatterned, layered dress with an apronlike piece of cloth that is diagonally striped, rather like her father's tie. Her large, cornelian necklace, apparently her mother's,[1] hangs down over her protruding belly. She gently grasps the right hand of her father, an elegantly dressed man. In contrast to his daughter, who is dressed in native costume, he wears Western attire: a suit with cuffed trousers, a shirt and tie, and dress shoes; a pith helmet is propped against his hip. He

both glances at the camera and beyond it. Each figure has a suggestion of a smile gracing the lips, but the girl's chin is tucked modestly into her neck while the man's posture is a subtly proud one. They stand on a dirt floor strewn with rocks. Behind them, a flat plane formed by a textile with an arabesque design creates an extremely shallow space somewhat resembling a stage backdrop; presumably, this is the impromptu photographer's studio.

The patterning behind the two figures serves a display function, not a psychological function, as in the case of the Vuillard. According to André Magnin, "Keïta says repeatedly that his only concern was to satisfy his customers by capturing their portraits as clearly and as favorably as possible. Each of his photographs carries an obligation. Each photograph fulfilled the wish of each person photographed. He made no effort to become acquainted with his subjects, who were making strictly private commissions for strictly personal use."[2] The photographer himself commented: "After all, the customer is only trying to look as good as possible. In Bamako we say *I ka nyé tan* which in English means 'you look well,' but in fact it means 'you look beautiful like that.' Art is beauty."[3]

This photograph, like Vuillard's painting, tells a story. It was taken in Bamako, the capital of the French Sudan, now known as Mali. The photograph and others document individuals and, in turn, the development of the urbanization of this important trading city. Thus, to be photographed by Keïta was to enter the modern age in West Africa and gain a position of esteem among one's contemporaries. For example, the pith helmet, either brought by the man or a simple prop in Keïta's studio, was a much sought-after object during this time and was itself a symbol of success. And, if the aim was to valorize the sitter, then a traditional studio photograph setting and composition were required, and the subjects needed to look attractive. Keïta said, "I always knew how to find the right position, and I never was wrong. Their head slightly turned, a serious face, the position of the hands.... I was capable of making someone look really good.... To have your photo taken was a special event. The person had to be made to look his or her best."[4]

Created some sixty-three years apart, both the painting by Vuillard and the photograph by Keïta offer contrasting images of modernity. The former, made in Paris during the age of Freud, shows two figures whose relationship is manifested in their pairing and in their setting. The latter, made in a former French colony in the immediate post-Colonial age, shows two figures whose status is manifested by the same means. In the former, the figures merge into their bourgeois surroundings; in the latter, they are contrasted against the patterned textile that simply forms their background. In each work a story is told through the relation of figures to ground, and in the relation between the figures.

1. Youssouf Tata Cissé in André Magnin, ed., *Seydou Keïta* (New York: Scalo, 1997), p. 281.
2. Magnin, "Introduction," in *Seydou Keïta*, p. 8.
3. Magnin, "Seydou's story" (interview by André Magnin, Bamako, 1995–96), in *Seydou Keïta*, p. 12.
4. Ibid., p. 11.

ÉDOUARD VUILLARD
Mother and Sister of the Artist. c. 1893.
Oil on canvas, 18¹/₄ x 22¹/₄" (46.3 x 56.5 cm).
The Museum of Modern Art, New York. Gift of
Mrs. Saidie A. May

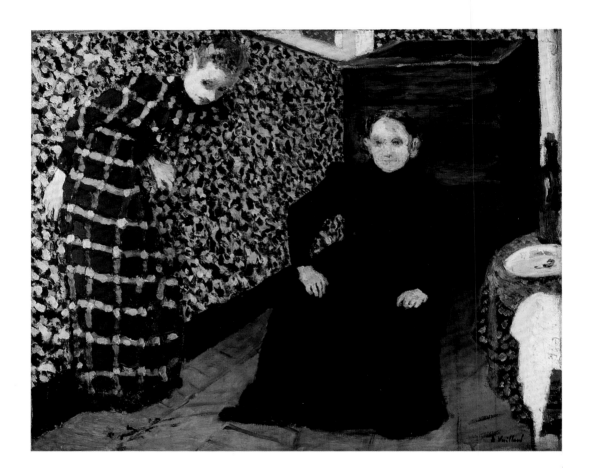

SEYDOU KEÏTA
Bamako. 1956–57.
Gelatin silver print, printed later, 21⁵/₈ x 15³/₄"
(54.9 x 40 cm). The Museum of Modern Art,
New York. The Family of Man Fund

JEAN DUBUFFET
Snack for Two. 1945.
Oil on canvas, 29$^1/_8$ x 24$^1/_8$" (74 x 61.2 cm).
The Museum of Modern Art, New York. Gift of
Mrs. Saidie A. May

AMEDEO MODIGLIANI
Bride and Groom. 1915–16.
Oil on canvas, 21³/₄ x 18¹/₄" (55.2 x 46.3 cm).
The Museum of Modern Art, New York. Gift of
Frederic Clay Bartlett

MAURICE GUIBERT
Toulouse-Lautrec. 1890s.
Gelatin silver print, 13¹³/₁₆ x 10¹/₄" (35.1 x 26.1 cm).
The Museum of Modern Art, New York. Anonymous gift

GERTRUDE KÄSEBIER
The Manger. 1899.
Platinum print, 12 x 9⅝" (32.4 x 24.4 cm).
The Museum of Modern Art, New York. Gift of
Mrs. Hermine M. Turner

MAX ERNST
**From *Une Semaine de Bonté, ou Les Sept Éléments
Capitaux* by Max Ernstan**.
Paris: Éditions Jeanne Bucher. 1934.
Line block reproduction after collage, 10³/₄ x 8¹/₁₆"
(27.3 x 20.5). Printer: Georges Duval, Paris. Edition:
821. The Museum of Modern Art, New York. The
Louis E. Stern Collection

José Guadalupe Posada
**The Man Hanged on the Street of Window Grilles,
Balvanera: Horrible Suicide, Monday January 8, 1892
(El ahorcado en la calle de las rejas de Balvanera.
Horrible suicidio el lunes 8 de enero de 1892)**. 1892.
Engraving, relief printed, comp.: 4⁵/₈ x 3⁷/₈" (11.7 x
9.8 cm). Publisher: Antonio Vanegas Arroyo, Mexico
City. The Museum of Modern Art, New York. Larry
Aldrich Fund

ERNST LUDWIG KIRCHNER
Two Nudes in a Landscape. c.1909–10.
Pastel, crayon, and charcoal on buff paper, 35¹/₄ x
27¹/₈" (89.5 x 69 cm). The Museum of Modern Art,
New York. Gift of Marshall S. Cogan

FERNAND LÉGER
Composition with Two Persons. 1920.
Lithograph, comp.: 11¹/₄ x 9⁵/₁₆" (28.6 x 23.7 cm).
Publisher: Gustave Kiepenheuer, Weimar. Edition:
125. The Museum of Modern Art, New York. Gift of
Edgar Kaufmann, Jr.

CLARENCE WHITE, *The Mirror*
EDVARD MUNCH, *The Young Model*

Maria del Carmen
González

Both of these pictures of single figures, in fact, show pairs of figures (pp. 108–09). In each case, the single figure is doubled—in one by her reflection, in the other by her shadow—and, in each case, the double gains a presence and a dimensionality that effectively makes it seem independent of its source. In the Clarence White photograph, light reflecting from the figure onto a mirror pairs the figure, not with the entirety of its replication in reverse, but with a framed fragment of it. In the Edvard Munch lithograph, light that is cut off by the figure pairs the figure not with a fully identifiable, opaqued silhouette, but with a curiously generalized version of it. In either case, the second repeated image is less a copy of the first than an interpretation of it.

The American photographer Clarence White's anonymous work titled *The Mirror*, of about 1909, shows a reclining woman, her arms stretched out as if to surround, virtually to embrace, an oval mirror that may be easily confused with a small pool of water. Both the gesture and the suggestion of water evoke the myth of Narcissus, who fell in love with his own image and metamorphosed into the flower that bears his name. White seems to allude to earlier representations of this myth, perhaps to the famous painting by Caravaggio. The myth also, of course, gives its name to narcissism. Less well known is the fact that it is one of the myths of how painting, and pictorial representation in general, was invented. White's photograph may consciously allude to that as well, for it makes a point of how the reflection copies and changes the source image as this photograph copies and changes its source.

The figure's face is turned away and gently rests upon her left shoulder. Just as her reflection is a fragment of her image, her own body, as pictured by White, does not fit into the frame of the photograph: her left leg is cropped off at the calf and her right arm reaches to the very border of the print. This close-cropped dark background allows the viewer very little distraction from the figure and the reflection. (The faint decorative patterning below the mirror seems to be an Oriental rug.) The figure, placed in the upper third of the picture and surrounded by murky darkness, invites the viewer to read this upper area as closest to the two-dimensional surface of the paper print and, in turn, closest to the viewer. The effect of the luminosity of the figure draws our gaze, and the mirroring beneath it serves to unfold the whole double image down onto the surface before us. The photograph, though drawing upon a European myth, takes its composition from the shallow space of Japanese prints rather than from the deep perspectives of Western art. This platinum print, White's preferred medium and a highly light-sensitive photographic method, allows a wide range of tonal values to be created. But White chose to emphasize subtle

differences in tone, not broad contrasts, in order to create the ambiguous mood of this work. Although he rarely manipulated his prints, White was obviously not simply interested in recording the nude. Rather, he chooses to offer a charged, metaphorically vivid image of the nude figure that is neither glamourized nor sentimental but, instead, transcends all its literary associations.

The same might be said of the Norwegian Edvard Munch's lithograph *The Young Model*, made in 1894, fifteen years earlier than White's photograph. Closely related to a painting by Munch called *Puberty*, it shows an adolescent nude female figure perched precariously at the edge of what seems to be a bed, with a dark form—part tumor, part phallus, part placenta—as well as a shadow rising beside and behind her. Her tightly crossed arms and clenched legs give her a highly self-protective, perhaps embarrassed quality, causing her to seem to retreat and withdraw from the viewer as well as to pull away from the apparition beside her. But the geometry of the setting pushes her image toward the viewer, and brings the apparition with it. It is a discomforting work with a tensely immobile figure and the ominous companion that seems to be growing out of her.

The lithographic technique itself contributes significantly to the specifically weighted-silhouetted form in the image, insofar as the ink-filled shadow is raised literally higher on the paper than the simply outlined figure beside it. (This is because only the drawn lines, done in grease crayon on the lithographic stone, are protected from the chemicals that burn the unmarked section of the stone before the stone is inked and run through the printing press.) The shadow is, therefore, more form than figure, so to speak. So is the space beneath the bed, which is what causes the figure to seem to be pushed forward of the surface.

Munch apparently worked directly from a model, which may account for the detail found in the face and head. But he was hardly interested in creating a naturalistic nude. Both his mother and his sister died when he was a child, and images of the sickroom are common in his work. So are images of anxious sexuality. This work combines both themes, as it alludes to the girl's experience of changes in her own body. Effectively, the shadow records that experience. Like the myth of Narcissus, alluded to in White's photograph, the drawing of a shadow on a wall, in Munch's lithograph, is one of the myths of how painting, and pictorial representation in general, was invented. Thus, Munch's work makes a point of how the shadow copies and changes the source image as this lithograph copies and changes its source. But the shadow in the Munch, unlike the reflection in the White, is so changed as to become fully an independent partner in the composition, an alternative self for the nude rather than a narcissistic reflection.

CLARENCE WHITE
The Mirror. c. 1909.
Platinum print, 9¹/₂ x 7⁵/₈" (24.2 x 19.4 cm).
The Museum of Modern Art, New York. John
Spencer Fund

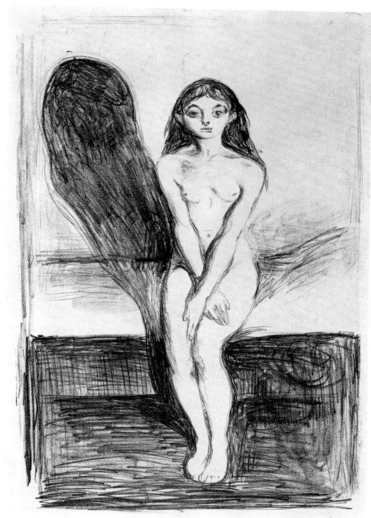

EDVARD MUNCH
The Young Model. 1894.
Lithograph, comp.: 16 1/8 x 10 3/4" (41 x 27.2 cm).
Printer: Liebmann. Edition: 8 known impressions.
The Museum of Modern Art, New York. The William
B. Jaffe and Evelyn A. J. Hall Collection

110 |

GEORGE STEVENS
Swing Time. 1936.
35mm, black and white, sound, 103 minutes.
The Museum of Modern Art, New York. Acquired
from RKO
Fred Astaire, Ginger Rogers

MARC CHAGALL
Birthday. 1915.
Oil on cardboard, 31³/₄ x 39¹/₄" (80.6 x 99.7 cm).
The Museum of Modern Art, New York. Acquired
through the Lillie P. Bliss Bequest

AUGUST SANDER
***The Painter Heinrich Hörle Drawing the Boxer Hein
Domgoren.*** 1927–31.
Gelatin silver print, 8¹⁵/₁₆ x 6⁵/₁₆" (22.8 x 16 cm).
The Museum of Modern Art, New York. Gift of
Paul F. Walter

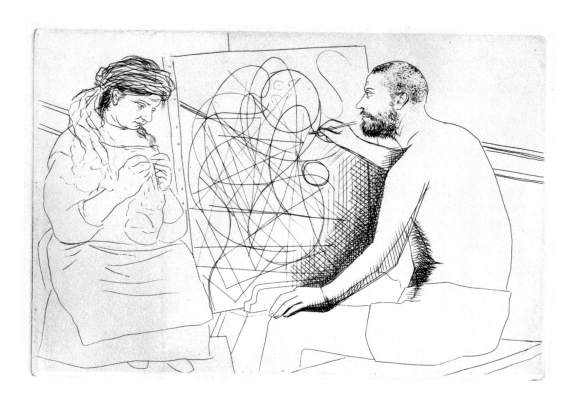

PABLO PICASSO
**Painter and a Model Knitting (Peintre et modèle
tricotant), plate IV from Le Chef-d'oeuvre inconnu
by Honoré de Balzac**. 1927, published 1931.
Etching, plate: 7⁹/₁₆ x 10¹⁵/₁₆" (19.2 x 27.8 cm).
Publisher: Ambroise Vollard, Paris. Printer: Louis
Fort, Paris. Edition: 340. The Museum of Modern Art,
New York. The Louis E. Stern Collection

MEHEMED FEHMY AGHA
Two Heads. 1940.
Gelatin silver print, 9⁹/₁₆ x 7⁵/₈" (24.2 x 19.4 cm).
The Museum of Modern Art, New York. Gift of Abby
Aldrich Rockefeller

W. Eugene Smith
Untitled. 1944.
Gelatin silver print, 13³/₈ x 10¹/₂" (34 x 26.7 cm).
The Museum of Modern Art, New York. Anonymous
gift. The Heirs of W. Eugene Smith/Black Star

ODILON REDON
Roger and Angelica. c. 1910.
Pastel on paper mounted on canvas, 36 $\frac{1}{2}$ x 28 $\frac{3}{4}$"
(92.7 x 73 cm). The Museum of Modern Art, New
York. Lillie P. Bliss Collection

CY TWOMBLY
Leda and the Swan. 1962.
Oil, pencil, and crayon on canvas, 6'3" x 6'6¾"
(190.5 x 200 cm). The Museum of Modern Art,
New York. Acquired through the Lillie P. Bliss
Bequest (by exchange)

GROUPS

Ernst Ludwig Kirchner, *Street, Dresden*
Edvard Munch, *Death Chamber*

M. Darsie Alexander

Edvard Munch's *Death Chamber* of 1896 and Ernst Ludwig Kirchner's *Street, Dresden* of 1908 illuminate the tensions of disparate worlds (pp. 122–23). Kirchner's painting captures the whirling energy of urban life, with anonymous crowds moving hurriedly past one another on city streets. Munch's print is set within the intimate confines of a bedchamber, where a family awaits the death of one of its members. In contrast to the intense activity of Kirchner's scene, Munch's is static, as if the figures were frozen in a state of debilitating helplessness. The absence of color does much to enhance this quality, just as the jarring palette of *Street, Dresden* underscores its lively rhythm. Yet beyond the dichotomies of public/private, outdoor/indoor, and color/monochrome, the compositions are structured in remarkably similar ways. Both employ the technique of a deeply receding space that is abruptly terminated by a lateral element at the back of the composition. Even more striking is the dominating foreground presence and confrontational attitude of the female subjects.[1] For both Munch and Kirchner, these figures act as a nexus for the psychological tension that pervades their images.

Munch's life inspired many of his most haunting works. *Death Chamber* (and a similar painting of 1893) was conceived in response to the illness and ultimate death of his older sister, Sophie, who succumbed to tuberculosis in 1877, when Munch was just fourteen. Produced nearly twenty years later, the print reflects the resounding impact of the event on the artist, who had already endured the loss of his mother in 1868. Though centered on the specific tragedy of the artist's sister, *Death Chamber* resonates with a pall of family grief and devastation. In the foreground, a woman glares out at the viewer with a look of one just risen from the dead, her arms hanging rigidly at her side. Her terrified countenance is offset by the featureless heads of surrounding figures, one of which appears to grow from her shoulders. In the left corner of the room, a boy stands by the door as if on the verge of leaving—or perhaps granting entrance to the invisible figure of Death. To the right, a second group shows an elderly man hovering over an unseen patient, his hands clasped in a gesture that evokes both pleading and prayer. All that is shown of the victim is the profile of her dress—a void of white. In *Death Chamber*, Munch describes a state of oppressive suffering from which there appears to be no escape.

Munch believed that the most compelling subjects were "people that were alive; that breathed and had emotions, that suffered and loved."[2] Rather than simply responding to visual stimuli, the artist called upon subjective experience to shape his art. To accommodate his preference for personal expression over objective analysis, Munch explored the possibilities of a wide

range of mediums. In 1894 he began his work in printmaking, a field in which he would distinguish himself as exceptionally experimental and adept. Lithography, a planar process capable of transcribing flat, abstract shapes, was ideal for Munch.[3] In *Death Chamber* the artist ingeniously exploits the qualities of positive and negative space afforded by the medium. The bodies of the foreground figures, for example, are symbolically fused into a mass of black form. Along the contours of the subjects' garments, the artist has incised the stone to create fine lines, inverting the definition of form from black to white. This print, devoid of color and exaggerated or extraneous detail, is rendered in the starkest form imaginable, accentuating the nightmarish experience of death.

The reverberating pitch and energy of *Street, Dresden* are altogether different from the somber mood of *Death Chamber*. The artist's selection of bright, unnatural colors to convey the vibrant, threatening pace of the city has an immediate impact on the viewer. Pavement rendered in hot pink fills the left side of the canvas, engulfing the figure of a little girl. To add to the intensity of his palette, Kirchner places antithetical hues in adjacent relationships: clashing mutations of reds and blues fill the image, electrifying the space. The artist's manipulation of the forces of opposition is apparent in other aspects of the picture: in the simultaneous approach and recession of subjects in space; the play between flatness and depth; and the creation of a strong diagonal that surges up from the left corner. These effects add to the unsettling quality of the painting and its account of city life. Here a mass of anonymous pedestrians rush down the sidewalk, avoiding even the slightest suggestion of exchange with their fellow travelers. Any sense of community is overrun by overt signs of fear and isolation: a woman clutches her pocketbook with a protective, clawlike hand; another lifts her skirt to facilitate a brisk, anxious stride. Kirchner's street is a spectacle of human activity and alienation.[4]

Munch and Kirchner expected more from art than the depiction of a comfortable, familiar world. On the contrary, their work stemmed from a desire to infuse visual form with a release of inner feeling. *Death Chamber* and *Street, Dresden* attest to the complex and separate realization of this ambition.

1. Some scholars have argued that the trancelike countenances and extreme frontal positions of the figures in *Street, Dresden* are based on Munch's painting *Evening on Karl Johan Street* (1892), though Kirchner adamantly denied the influence of Munch's "gloomy, misanthropic pictures." See Donald E. Gordon, *Expressionism: Art and Idea* (New Haven and London: Yale University Press, 1987), p. 29.

2. Øivind Storm Bjerke, *Edvard Munch/Harald Sohlberg: Landscapes of the Mind* (New York: National Academy of Design, 1995), p 25.

3. The lithographic process is based on the resistance of grease and water. A drawing is made with a greasy crayon or tusche (an ink applied with a brush) on limestone. A chemical mixture is then applied to the stone in order to bond the greasy drawn image securely to the surface. Next, the stone is covered with a thin film of water, which is absorbed by the untouched limestone but rejected in the drawn areas. When printer's ink is rolled across the stone's surface, it is retained only in the greasy drawn areas. Finally, the stone is covered with a sheet of paper onto which the image is transferred when both are passed through a press. For more information on Munch's printmaking, see Elizabeth Prelinger, *Edvard Munch: Master Printmaker* (New York and London: W.W. Norton in association with the Busch-Reisinger Museum, Harvard University, 1983).

4. Kirchner's creative energy and outlook attracted him to like-minded students at the Technische Hochschule in Dresden, where he studied architecture. In 1905 they formed the group *Die Brücke* (The Bridge). Largely self-taught, the members rejected academic formalism and superficial decoration in favor of a direct and intuitive response to immediate sensation. Their work became the basis for a youthful avant-garde style in Germany known as Expressionism.

Ernst Ludwig Kirchner
Street, Dresden. 1908, dated on painting 1907.
Oil on canvas, 59¹/₄" x 6' 6⁷/₈" (150.5 x 200.4 cm).
The Museum of Modern Art, New York. Purchase

EDVARD MUNCH
Death Chamber. 1896.
Lithograph, comp.: 15¹/₄ x 21⁵/₈" (38.7 x 55 cm).
Edition: approx. 100. The Museum of Modern
Art, New York. Gift of Abby Aldrich Rockefeller
(by exchange)

AUGUSTE RODIN
The Three Shades. 1881–86.
Bronze, 38³/₈ x 36³/₈ x 19¹/₂" (97.3 x 92.2 x 49.5 cm).
The Museum of Modern Art, New York. Mary Sisler
Bequest

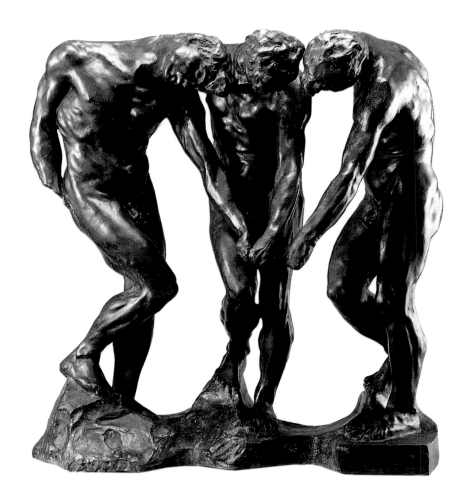

HENRI MATISSE
Dance (first version). 1909.
Oil on canvas, 8' 6 ¹/₂" x 12' 9 ¹/₂" (259.7 x 390.1 cm).
The Museum of Modern Art, New York. Gift of
Nelson A. Rockefeller in honor of Alfred H. Barr, Jr.

PABLO PICASSO
Three Women at the Spring. 1921.
Oil on canvas, 6' 8 1/4" x 68 1/2" (203.9 x 174 cm).
The Museum of Modern Art, New York. Gift of
Mr. and Mrs. Allan D. Emil

FERNAND LÉGER
The Three Musicians. 1944 (after a drawing of
1924–25; dated on canvas 24–44).
Oil on canvas, 68$^1/_2$ x 57$^1/_4$" (174 x 145.4 cm).
The Museum of Modern Art, New York. Mrs. Simon
Guggenheim Fund

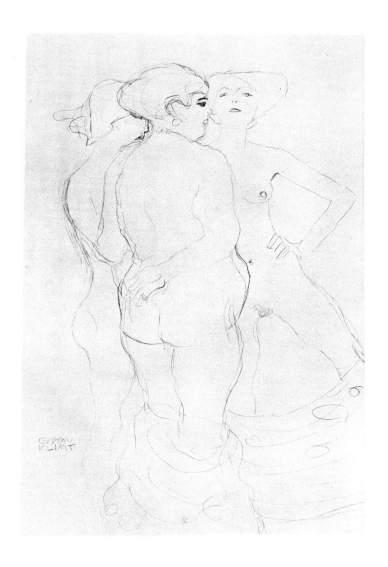

GUSTAV KLIMT
Three Courtesans. 1907–10.
Pencil on paper, 22 x 14 1/2" (55.9 x 36.7 cm).
The Museum of Modern Art, New York. Mr. and
Mrs. William B. Jaffe Fund

ALBERTO GIACOMETTI
Three Men Walking, I. 1948–49.
Bronze, 28¹/₂ x 16 x 16³/₈" (72.2 x 40.5 x 41.5 cm),
including base, 10⁵/₈ x 7³/₄ x 7³/₄" (27 x 19.6 x
19.6 cm). The Museum of Modern Art, New York.
The Sidney and Harriet Janis Collection

Louise Bourgeois
Quarantania I. 1947–53, reassembled by artist 1981.
Painted wood on wood base, 6' 9¹/₄" (206.4 cm)
high, including base 6 x 27¹/₄ x 27" (15.2 x 69.1 x
68.6 cm). The Museum of Modern Art, New York.
Gift of Ruth Stephan Franklin

WIFREDO LAM
The Jungle. 1943.
Gouache on paper mounted on canvas, 7' 10" x
7' 6 ¹/₂" (239.4 x 229.9 cm). The Museum of Modern
Art, New York. Inter-American Fund

CHARLES RAY, *Family Romance*
TINA BARNEY, **Untitled**

M. Darsie Alexander

Tina Barney and Charles Ray investigate the human body through radically different artistic means (pp. 134–35). Ray's works are encountered as free-standing, three-dimensional objects; Barney transforms physical reality into the two-dimensional form of a photographic print. Yet despite their dissimilar approaches, both artists render the physical attributes of their subjects with scrupulous precision, drawing out the familiar qualities of the human body as well as exposing its more subtle (and, for Ray, unnatural) flaws.

Barney, who is best known for her narrative photographs of friends and family, broke temporarily from this genre in 1996 to work on a limited series of nudes. Her goal was to investigate the human figure outside the context of a deeper plot or narrative. By hiring models to pose for her rather than pho-tographing people she knew personally, Barney defined a new set of ground rules that allowed her to work from the position of a disinterested observer. Rather than photograph within the confines of a familiar environment, Barney went to her subjects' homes to work.[1] Once situated with her lighting and equipment, she encouraged her models to move freely before the camera, and to respond to it according to their own instincts. The poses adopted in this image, which the artist describes as "impromptu," attest to how various attitudes and emotions are manifest in body language. To the right, a slouched figure with splayed legs and crossed arms communicates a self-conscious awkwardness through his closed gestures and downcast eyes. Beside him a woman leans her head to one side in a manner that evokes boredom and fatigue. The only subject to completely engage the photographer is at the left, whose countenance belies a confident demeanor. As Barney's picture suggests, people display various levels of ease before the camera, which are determined by factors such as timing, environment, and the subjects' states of mind. Though some of these elements can be controlled, photography owes much to the effects of natural occur-rence—as it does here in the languid, casual manner in which the subjects present themselves to the camera.

Ray's *Family Romance*, by contrast, presents an ordered if not regimented contingent of bland bodies—an inanimate counterpart to the flesh and blood immediacy of Barney's subjects. Basing his work on an idealized image of the nuclear family, Ray transforms it into a strange lineup of fiberglass mannequins. On one level, the work is a vision of familial harmony, with each member symbolically linked through clasped hands. The "father" figure, whose mature face and slight paunch hint at impending middle age, stands next to his curva-ceous wife. They are accompanied by their baby-faced children, a boy and a girl, symbolic of youth's innocence. Yet there is something profoundly amiss about

this carefully rendered foursome that is borne out in the features of their anatomy. The children's bodies are oddly elongated, making them as tall (and as important) as their parents. While some aspects of their physiques are highly specific, other qualities are indistinguishable. The parents' faces, for example, possess an uncanny similarity, seeming to belong to one individual, mutated into feminine and masculine counterparts. As a result of these subtle and not-so-subtle defects, Ray disrupts the placid veneer of this model family.

Ray's use of the mannequin plays upon viewers' uneasy response to this disturbing, though familiar, icon. As a freshman in college, Ray worked in a department store, where he observed that shoppers alternatively perceived mannequins as inanimate objects and living beings.[2] The startling realization that something seen as human is actually a life-size imitation was the kind of perceptual double-take that intrigued Ray. When he introduced the mannequin into his art around 1990, he explored its visual and psychological possibilities. On the one hand, a mannequin is a neutral and everyday object. On the other, it is unnerving and ambiguous, capable of disturbing the boundaries between artifice and reality.

Interpretation of these works is shaped by how the subjects are presented, their physical arrangement and context. Ray has chosen to place his figures in a line, a strategy that emphasizes orderliness and regularity. The individual members are evenly spaced, with their dropped arms forming a succession of V-shapes. Measuring at a consistent 4' 5", they are balanced in age, number, and gender. As such they imply a law of averages, not just amongst themselves but within broader standards of "normalcy." By presenting the viewer with one version of the American family—white and, by implication, middle class—Ray raises the question of what comprises the "typical" domestic unit. Barney's photograph, by comparison, does not reflect upon generalizations. Instead she focuses on the qualities that differentiate people, that define individuality. Each of her models, for example, is of a slightly different weight and body type. These properties are enhanced by the way the subjects pose—the way they hold their bodies and direct their gazes. The cumulative effect is a complicated and organic configuration of angles and overlapping body parts, a direct counterpoint to the unsettling display of sameness that underlies Ray's *Family Romance.*

Both Barney and Ray remove the subjects entirely from the sexual and erotic themes that frequently appear in depictions of the nude. Instead, a sense of awkwardness underlies human contact in these works. Barney's subjects are situated in close proximity to one another but they barely touch. Signs of familial warmth are also absent from *Family Romance*, in which contact is restricted to a stiff grasp of hands. Thus through their respective mediums, the artists suggest the difficulties of human interaction.

1. Background information on this series was obtained in a telephone interview with the artist on June 10, 1999.
2. Paul Schimmel, *Charles Ray* (Los Angeles and Zurich: The Museum of Contemporary Art and Scalo Verlag, 1998), p. 83.

CHARLES RAY
Family Romance. 1993.
Mixed media, 53" x 7'1" x 11" (134.6 x 215.9 x 27.9 cm).
The Museum of Modern Art, New York. Gift of The
Norton Family Foundation

TINA BARNEY
Untitled. 1996.
Chromogenic color print, 14¹/₂ x 18¹/₄" (36.8 x
46.3 cm). The Museum of Modern Art, New York.
Gift of Ken Kuchin

Max Weber
Three Bathers. 1909.
Gouache on paper, 7¹/₄ x 8⁷/₈" (18.6 x 22.7 cm).
The Museum of Modern Art, New York. The Joan
and Lester Avnet Collection

ANDRÉ DERAIN
Bathers. 1907.
Oil on canvas, 52" x 6' 4³/₄" (132.1 x 195 cm).
The Museum of Modern Art, New York. William S.
Paley and Abby Aldrich Rockefeller Funds

ATTILIO SALEMME
Southwest. 1948.
Pen and ink on paper, 8¹/₂ x 11" (21.5 x 27.9 cm).
The Museum of Modern Art, New York. Gift of
John S. Newberry

1923 212 Scene unter Mädchen

PAUL KLEE
A Stage for the Use of Young Girls. 1923.
Watercolor, gouache, pen and ink, and pencil on
paper mounted on cardboard, 19 1/2 x 12 5/8" (50 x
32.1 cm). The Museum of Modern Art, New York.
The Joan and Lester Avnet Collection

AUGUST SANDER
Family Group. 1912.
Gelatin silver print, 8⁵/₈ x 11³/₈" (14.3 x 28.9 cm).
The Museum of Modern Art, New York. Gift of the
photographer

DIANE ARBUS
A Young Brooklyn Family Going for a Sunday Outing,
New York City. 1966.
Gelatin silver print, 15¹/₂ x 14 ⁷/₈" (39.3 x 37.7 cm).
The Museum of Modern Art, New York. Lily
Auchincloss Fund

José Clemente Orozco
The Masses. 1935.
Lithograph, comp.: 13⁷/₁₆ x 16⁷/₈" (34.1 x 42.9 cm).
Edition: 120. The Museum of Modern Art, New York.
Inter-American Fund

WEEGEE (ARTHUR FELLIG)
Coney Island. 1938.
Gelatin silver print, 10⁹/₁₆ x 13¹¹/₁₆" (26.9 x 34.8 cm).
The Museum of Modern Art, New York.
Anonymous gift